T0124869

LOOKING AT
EUROPEAN SCULPTURE

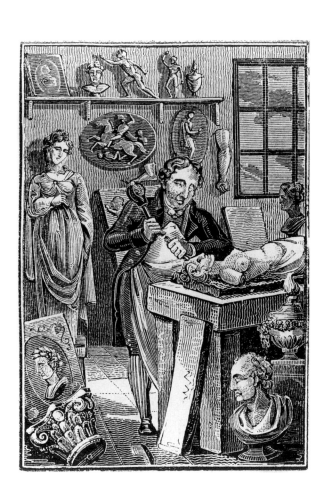

LOOKING AT

EUROPEAN SCULPTURE

A GUIDE TO TECHNICAL TERMS

Jane Bassett and Peggy Fogelman

THE J. PAUL GETTY MUSEUM

IN COLLABORATION WITH

THE VICTORIA AND ALBERT MUSEUM

©1997 The J. Paul Getty Museum and the Board of Trustees of the
Victoria and Albert Museum
Second printing, 2007
Published by the
J. Paul Getty Museum
1200 Getty Center Drive
Suite 1000
Los Angeles, California 90049–1687

At the J. Paul Getty Museum:
Christopher Hudson, Publisher
Mark Greenberg, Managing Editor

At the J. Paul Getty Trust Publication Services:
Richard R. Kinney, Director
Deenie Yudell, Design Manager
Karen Schmidt, Production Manager

Library of Congress Cataloging-in-Publication Data

Bassett, Jane.
 Looking at European sculpture : a guide to technical terms / Jane
Bassett and Peggy Fogelman.
 p. cm. – – (Looking at)
 Includes bibliographical references.
 ISBN 0–89236–291–X
 1. Sculpture – – Dictionaries. I. Fogelman, Peggy. II. J. Paul
Getty Museum. III. Victoria and Albert Museum. IV. Title.
V. Series.
NB50.B37 1997
730′.3– –DC21 96–39855
 CIP

Copyright of the illustrations is indicated in the captions by the
initials JPGM (J. Paul Getty Museum), V&A (The Board of Trustees
of the Victoria and Albert Museum), or by the name of the institu-
tion owning the work illustrated.
Printed in China
Cover: *Corpus from a Crucifix* (detail), Flemish, c. 1680–1720. JPGM,
82.SD.138.1. (See entry and illustration under WOOD.)

Frontispiece: "Statuary" from *The Book of English Trades and Library of
the Useful Arts* (printed for C & J Rivington, London, 1827), unnum-
bered illustration.

The purpose of this book is to clarify the meanings and applications of terms relating to European sculpture. It is our hope that the brief definitions presented here will be equally useful to museum visitors and staff, to students as well as scholars, and to anyone interested in knowing more about the creation of a sculpted work of art. The terms—which are necessarily limited in number by the length and size of a book intended to be carried easily around the galleries—are those most apt to appear in catalogue texts or on labels within a museum.

The scope of this book is very specific and has been chosen to reflect the holdings of the Department of Sculpture and Works of Art at the J. Paul Getty Museum, which include European sculpture from the Renaissance through the nineteenth century. The illustrations, which provide visual examples of specific terms and techniques, reproduce objects from the two institutions serving as copublishers: the Getty Museum and the Victoria and Albert Museum in London, which contains one of the most extensive and important sculpture collections in the world. Processes or descriptive words exclusive to medieval or twentieth-century European sculpture, or to non-European works of art, have been omitted. Nevertheless, many sculptural techniques have remained in use more or less unchanged from antiquity to the present day, and their definitions may help elucidate aspects of sculpture from other periods or cultures. Although subtitled *A Guide to Technical Terms*, the book includes many terms that are art historical rather than technical. These terms, however, have particular meanings when applied to sculpture as opposed to other media and were therefore thought appropriate for a book devoted to sculpture as a unique branch of artistic endeavor.

We would like to express our sincere gratitude to Paul Williamson, Chief Curator, and to Peta Evelyn, Deputy Curator, of the Sculpture Department at the Victoria and Albert Museum, London, for their insightful comments on the text and invaluable assistance in tracking down illustrations. We are equally indebted to Alexander Kader of the Victoria and Albert Museum for providing access to specific objects and arranging new photography

where needed. Jack Soultanian, Conservator of Sculpture at the Metropolitan Museum of Art, provided many suggestions and perceptive comments. We also wish to thank Jonathan Thornton, Professor of Art Conservation at the State University College at Buffalo, for his generous help on the text as well as his recommendations for the historical illustrations. We are indebted to Joe Godla, Gordon Hanlon, Abigail Hykin, and Cynthia Moyer of the Getty Museum's Department of Decorative Arts and Sculpture Conservation and to Francesca Bewer, Eric Hansen, Carlos Rodriguez-Navarro, and David Scott of the Getty Conservation Institute for their assistance on several technical points. Marietta Cambareri, Graduate Intern in the Department of Sculpture and Works of Art, also provided thoughtful observations on specific passages and illustrations. We would also like to extend our thanks to the following people, who helped in a variety of ways: Cynthia Newman Bohn, Mike Fair, John Harris, Lou Meluso, Jack Ross, and Manny Spira. Finally, we are most grateful to Peter Fusco, Curator of Sculpture and Works of Art, and Brian Considine, Conservator of Decorative Arts and Sculpture, at the Getty Museum for their sound advice and encouragement.

Jane Bassett
Peggy Fogelman

AFTERCAST
(FRENCH, *SURMOULAGE*)

A bronze sculpture cast using MOLDS taken from a pre-existing work in bronze rather than from the original MODEL. An aftercast is later in date and slightly smaller than the bronze from which it was derived; the reduction in dimensions in the aftercast occurs because molten metal shrinks as it cools. The process of taking molds from an existing bronze may result in the softening or loss of surface detail. Although this deficiency can be somewhat compensated for by careful CHASING, it nevertheless explains why aftercasts are usually considered to be of diminished quality. See also LOST WAX CASTING.

ALABASTER

A fine-grained translucent sedimentary stone composed of hydrous calcium sulfate (principally or entirely hydrous $CaSO_4 \cdot 2H_2O$) that varies in color from white to yellowish or

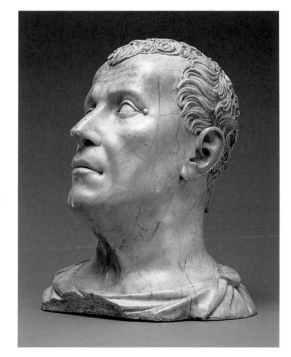

ALABASTER
Attributed to Conrat Meit
(German, 1480s?–1550/51).
Head of a Man, c. 1520.
Alabaster, H: 33 cm (13 in.).
JPGM, 96.SA.2.

Note Words printed in
SMALL CAPITALS refer to
other entries in the book.

pink, occasionally displaying veins or cloudy inclusions. The term has sometimes been applied to hard fine-grained stones such as yellow onyx (*giallo antico*), which is composed of calcium carbonate and therefore is not, according to modern classifications, an alabaster. True alabaster is a soft stone with the potential for finely detailed carving and can be polished. However, it is easily damaged by water and abrasion. Alabaster was a popular stone for TOMB effigies and RELIEF sculpture, especially in northern Europe from the Middle Ages until the sixteenth century.

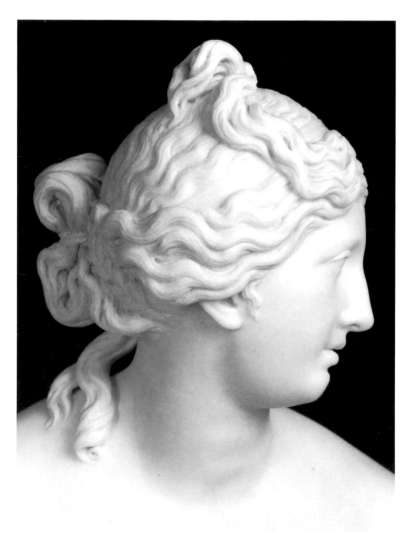

ALL' ANTICA

Joseph Nollekens (British, 1737–1823). *Venus* (detail of head), 1773. Marble, H: 124 cm (48 13/16 in.). JPGM, 87.SA.106.

Nollekens derived the ALL' ANTICA hairstyle of this goddess from examples found in ancient sculpture.

ALL' ANTICA
(ITALIAN, "AFTER THE ANTIQUE")

A term used to describe a work of art, or any portion thereof, which is inspired by or emulates ancient Greek or Roman precedents. The adjective might describe a small detail or motif, such as the hairstyle of a sculpted figure, or an entire composition based on an ancient source.

ALLOY

A mixture of two or more metals that have been melted together. Metals are alloyed in order to alter characteristics such as color, hardness, corrosion resistance, melting point, malleability, and strength. Often alloying one metal with another sacrifices a property of the original, pure, metal, such as malleability, in favor of other desired properties, such as a lowered melting point, which is useful in casting.

ANDIRONS

See FIREDOGS.

ANIMALIER

A French term for sculpture depicting an animal or group of animals (usually in bronze) or for a sculptor who specializes in subjects of this type. The term refers most frequently to a group of nineteenth-century French sculptors, whose work combined the faithful observation of nature and minute attention to realistic details with a dramatic characterization of the animal world, often emphasizing the violent or predatory aspects of the subjects.

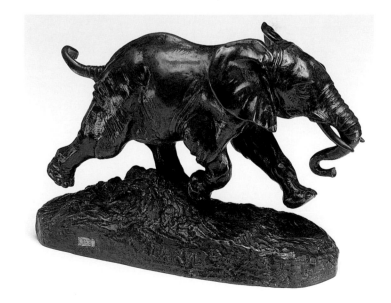

ANIMALIER
Antoine-Louis Barye
(French, 1796–1875).
Elephant of Senegal, c. 1880.
(Founder: Ferdinand
Barbedienne [French,
1810–1892]). Bronze,
H: 14 cm (5½ in.);
L: 19 cm (7½ in.).
V&A, 62–1882 (S.Ex).

ARMATURE

Giovanni Bologna, called
Giambologna (Flemish, active
in Florence, 1529–1608).
Preparatory model for *The
Triumph of Florence over Pisa*,
1565. Red wax, H: 22.2 cm
(8¾ in.). V&A, 4118–1854.

The metal ARMATURE of
Giambologna's preparatory
model can be seen in this
radiograph (X-ray) (at right),
where it appears as a solid
white vertical rod with finer
wire wrapped around it.

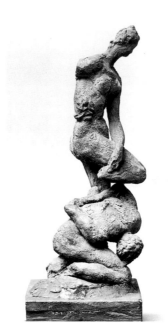
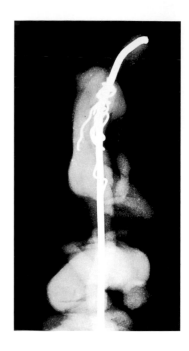

ARMATURE

An internal skeleton, usually of metal or wood, which supports a sculpture in CLAY, PLASTER, or other modeling material during its construction. Metal armatures are also used as internal supports for large metal monuments. The armature usually consists of a central, rigid element onto which the main mass of the sculpture is MODELED. Wires or padding are attached to the central component to support projecting forms such as limbs. An armature serves both to bear the weight of the sculpture and to maintain the positions and forms of the compositional elements as the sculpting material hardens. In LOST WAX CASTING, the armature, which extends from the base up into part or all of the sculpted composition, should be distinguished from the *core supports*, which are separate, shorter pieces of wire or rod added to strengthen isolated sections of the core. Metal armatures in clay sculptures are always removed before firing, since expansion of the metal as it is heated will cause the clay to crack. In order to reduce the weight of cast bronze sculptures, metal armatures used in the build-up of the core are often removed after casting, when the support is no longer needed. On the other hand, armatures contained in plaster and WAX sculptures are not easily removed and add needed strength to the finished work. Iron armatures left in sculpture can be the cause of damage due to rusting of the iron. When present, armature remnants can be detected through the use of radiography (X-rays).

ATLANTES

See CARYATID.

An accessory that identifies or characterizes a figure or group of figures. Costumes, objects held in the hand, and accompanying animals are all examples of attributes. Attributes of mythological figures specify the deity and symbolize aspects of the god's temperament and power. For example, a scepter, flaming thunderbolts, and an eagle distinguish the Roman god Jupiter, supreme ruler of the Olympian deities. In Christian devotional sculpture, saints are often portrayed with the attributes of their

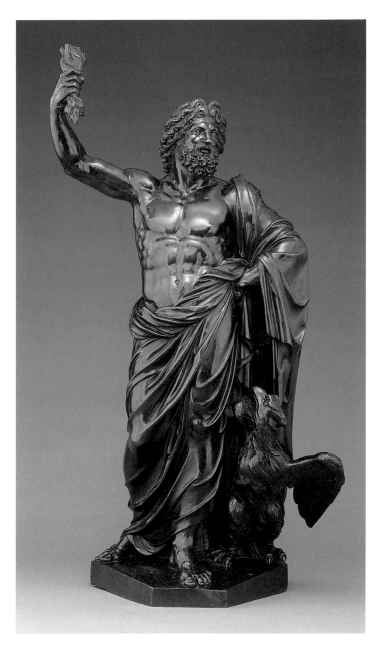

ATTRIBUTE

Michel Anguier (French, 1612–1686). *Jupiter*, cast in the second half of the 17th century from a model of 1652. Bronze, H: 61 cm (24 in.). JPGM, 94.SB.21.

The eagle and thunderbolts are ATTRIBUTES that identify the figure as the Roman god Jupiter.

martyrdom, both to identify them and to inspire the worshipper. Saint Bartholomew, for instance, is typically shown holding a knife and his flayed skin. Attributes also elucidate the abstract concepts conveyed by symbolic figures, as in the scales held by Justice or the wheel accompanying Fortune. In portraiture, accessories that establish the profession, status, or personality of the sitter, or associate the sitter with a classical god or symbol, are also known as attributes.

ATTRIBUTION

The assignment of a work of art of unknown authorship to a particular artist, school, or nationality. Many sculptures are neither signed nor dated, or they have been removed from their original settings. Art historians may attribute a sculpture based on an assessment of its FACTURE, scientific analysis of the materials and techniques of its execution, interpretation of relevant documentary evidence, and/or a consideration of its stylistic similarities to works of known authorship.

BASE

See SUPPORT.

BIER

A stand that supports a corpse or coffin. Representations of a corpse laid out on a funeral bier occur in TOMB sculpture.

BOZZETTO

See SKETCH and MODEL.

BRASS

An ALLOY of copper and zinc, usually containing varying amounts of other metals such as lead and tin. Brass varies in color from pale to golden yellow. Until the eighteenth century, brass usually contained from 10 to 28 percent zinc. If the alloy dates from after about 1740, when methods of refining pure zinc were developed in Europe, it may contain up to 40 percent zinc. Brass is less malleable but stronger, harder, and easier to cast than pure copper. It was used for the production of utilitarian objects such as candlesticks, bells, and bowls, as well as for cast sculpture. Sculptures that are technically brass alloys are often classified as bronze. This is in part because it is difficult to visually distinguish the difference between the two and in part, perhaps, because of the association of brass with the production of utilitarian ware rather than fine art. Further confusion arises since many brass alloys contain a considerable amount of tin, which is the defining component of BRONZE. Generally, the term *bronze* has been used for all fine art sculpture and predominates in art historical literature.

Bronze	An ALLOY of copper and tin, generally with a tin content of between 5 and 14 percent. The strength, corrosion resistance, and brittleness of bronze increases in proportion to the tin content. Bronze is reddish in color, becoming whiter as more tin is added. Zinc and lead are often included in bronze alloys in order to lower the melting point and reduce the shrinkage of the cast bronze; lead also increases the fluidity of the melted metal and makes the bronze easier to chisel and work after casting. Although bronze can be coldworked—spun on a LATHE, hammered, or chiseled—most three-dimensional and RELIEF sculpture is made by casting the molten metal into MOLDS. Renaissance and later European sculpture was most often cast using the LOST WAX method, but occasionally the SAND CASTING technique was used. The casting method chosen for an individual sculpture was influenced by the size and complexity of the MODEL as well as by local tradition. The tensile strength of bronze allows the creation of extended compositions without the use of SUPPORTS (which would be necessary if the work were made of marble, wood, or terra-cotta). Therefore, certain subjects or compositional arrangements, for example, a horse rearing on two legs, lend themselves to expression in bronze. Finished bronzes can be given a chemical PATINA and/or coated to hide imperfections and to protect the polished surface. Additionally, a bronze can be partially or fully GILDED or silvered. The luster and durability of bronze make it the preferred medium for small sculpture that is intended to be picked up, handled, and admired from many viewpoints. See also BRASS.
Bronze casting	See LOST WAX CASTING and SAND CASTING.
Bronzing	Coating a surface to give it the appearance of bronze, generally through the application of metallic powders (usually copper or copper ALLOYS such as brass); the powder may be mixed into a paint medium such as linseed oil and brushed on, or the surface may be coated with a tacky substance and the powder dusted on. A work made of an inexpensive material like wood might be treated to look like cast bronze, and artists frequently bronzed their preparatory plaster models as a means of approximating the appearance of the final cast bronze. Plaster casts of finished sculptures were often bronzed and served as inexpensive reproductions which were popular in the nineteenth century. The term *bronzing* is sometimes used to refer to the coating of a surface with bronze or copper leaf or to ELECTROPLATING a surface with a copper alloy.

A finishing technique for smoothing and polishing a surface without removing any material by rubbing it with a hard, smooth tool. Water-gilded surfaces are burnished using an agate-tipped tool, which smoothes the *bole* layers (see GILDING) to give the gold a mirrorlike polish. Cast metal surfaces can be burnished with steel tools (see CHASING). Clay that is hard but still damp can be burnished with wooden tools to create a smooth surface which retains its polish after firing.

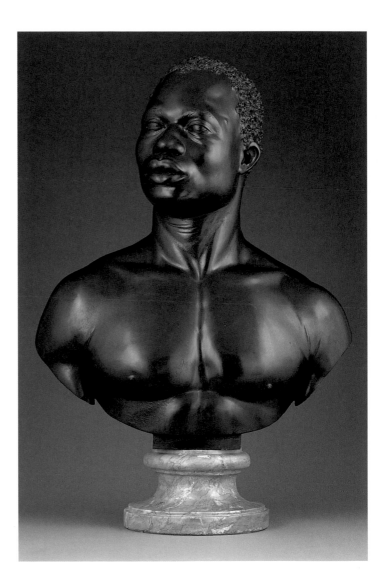

BUST
Francis Harwood (British, active in Florence 1748–69). *Bust of a Man*, 1758. Black sandy limestone on Siena marble SOCLE, H: 70 cm (27 ½ in.).
JPGM, 88.SA.114.

BUST

A three-dimensional partial representation of a real, imagined, or symbolic human figure that concentrates on the head—the locus of intellect and personality—and some portion of the chest (see TRUNCATION). The arms may or may not be included, but the lower torso and legs are by definition excluded. The sculpted bust is an inherently artificial format because of its incompleteness. It assumes the willingness of the viewer to accept the fragment as a convincing part of the whole and to complete the missing portions in his or her own imagination. Most sculpted busts are PORTRAITS, a use derived from ancient Roman tradition and revived in the Renaissance, and they often bear adornments that indicate the identity, status, or symbolic meaning of the figure represented (see ATTRIBUTE). The chest of a sculpted bust may be nude, clothed, or draped.

CARTOUCHE

Sculpted ornament in the form of a scroll rolled at both ends, bearing an INSCRIPTION or emblem. By extension, any ornamental framing device for a space designated to receive an inscription or emblem. In the case of a sculpted BUST placed on a SOCLE, the transitional element (where one exists) at the top of the socle is also known as a cartouche, both because of its form and because it was often reserved for inscriptions or RELIEF decoration relevant to the bust it supported.

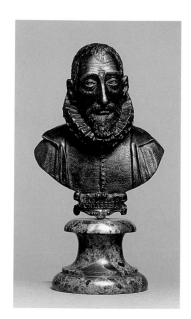

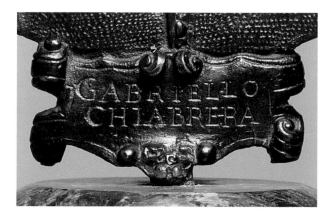

CARTOUCHE
Pompeo Caccini (Italian, active 17th century). *Bust of Gabriello Chiabrera*, 1624. Bronze, H: 19.7 cm (7¾ in.); W: 13.4 cm (5¾ in.). V&A, A.8–1990.

In this bust a CARTOUCHE bearing an INSCRIPTION appears below the chest.

CARVING

The removal of material to reveal a form, a process often contrasted with MODELING, which involves the addition of material to build a form. Among the most popular European carving materials from the Renaissance through the nineteenth century were MARBLE, WOOD, and IVORY. The hand tools and techniques used to carve these materials have changed little since antiquity and essentially involve the application of force to a sharpened cutting edge. Marble carvers use drills as well as a variety of iron tools, which are struck with heavy mallets or, since the early twentieth century, powered by compressed air. Wood can be carved by applying hand pressure on knives, chisels, and gouges, by striking chisels and gouges with wooden mallets, or by filing or drilling. The tools and techniques for carving ivory are similar to those for wood, but levered scraping tools and files are more commonly employed. Although plaster and clay sculptures are often built by modeling or casting, their surfaces can be carved once the material has begun to harden.

CARYATID

A figure used in lieu of a column or pilaster as a vertical supporting element. Caryatid figures can be traced to ancient Greece and enjoyed a widespread revival in European art from the Renaissance onward, occurring in exterior architecture (e.g., framing doors and windows), interior architecture (e.g., on TOMBS or as supports for fireplace mantels), and furniture. The term may have its origins in Greek history. According to the ancient author Vitruvius, the use of female figures as subordinate architectural elements, forced to bear the weight of a lintel, derived from the enslavement by the Greeks of women of Caryae, a town in Laconia. According to another ancient source, Pausanias, the women of Caryae performed dances in honor of Artemis, and it was this ritual that inspired the form of caryatid figures. Both associations are preserved in European art: enslaved caryatids bound by chains derive from the former explanation, whereas the use of fauns, nymphs, satyrs, and other mythological creatures of the woods as caryatid figures evoke the hunting goddess Artemis. Strictly defined, caryatids are female (male supporting figures are called *atlantes* after the Titan Atlas), but the term is used loosely to designate both male and female vertical supports.

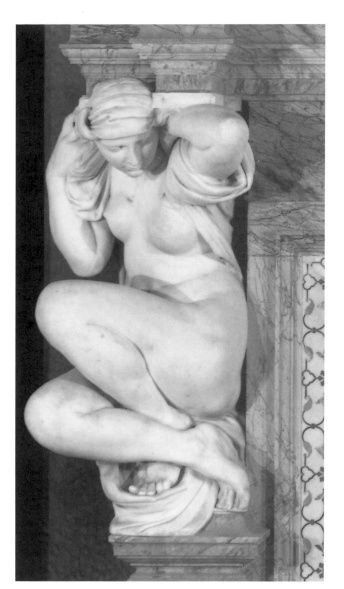

CARYATID

Alfred Stevens (British, 1817–1875). *Model for a Marble Mantelpiece in Dorchester House* (detail), c. 1860–69. Plaster, H: 457 cm (15 ft.); W: 305 cm (10 ft.). V&A, 129–130–1879.

This crouching CARYATID was intended for use as the vertical supporting element below the mantel of a fireplace.

CAST-IN REPAIR

Metal fills poured into a sculpture after its initial casting. Flaws in a cast surface may occur because of trapped gas or overly rapid cooling of the molten metal, which restricts its flow into a section of the mold. Although small repairs can be made by evening the edges of the imperfect area and mechanically inserting a patch or plug, larger flaws may require a cast-in repair in order to fill areas that were not formed properly during the initial casting. Cast-in repairs can be accomplished by partially excavating the CORE and pouring in an excess amount of metal, which can then be leveled to match the surrounding surface. For sculptures created using the LOST WAX CASTING technique, when an entire projection

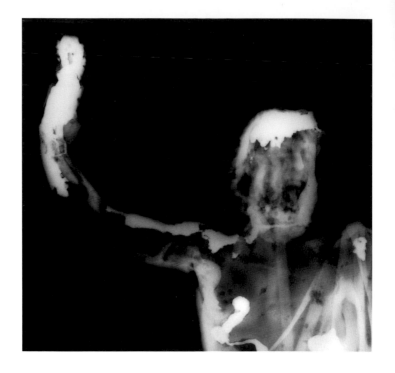

CAST-IN REPAIR
Michel Anguier (French, 1612–1686). *Jupiter,* cast in the second half of the 17th century from a model of 1652. Bronze, H: 61 cm (24 in.). JPGM, 94.SB.21.

In this radiograph (X-ray) of the bronze sculpture illustrated under ATTRIBUTE, the dense white areas at the top of the head, in the raised shoulder, and in the body indicate large casting flaws that were filled with lead as a simple form of CAST-IN REPAIR.

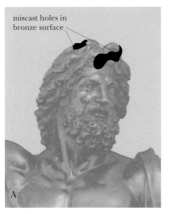
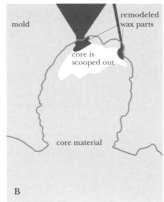
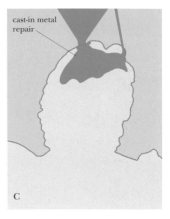

Diagram of a CAST-IN REPAIR (Courtesy of F. Bewer).
A. When this bronze was cast, the molten metal did not flow evenly to all parts of the figure, leaving some holes in the head.
B. A large area of the core is scooped out through these holes; the holes are filled with wax repairs that follow the contours of the head; a pouring cup and vent are added; and the head is encased in an outer mold.
C. After the wax has been melted out of the mold, bronze is poured in; the mold is removed; the pouring cup and vent, which are now solid bronze, will be removed and the repair will be chased.

such as a foot or hand is incompletely cast, a wax model of the missing limb can be attached to the bronze, a SPRUE attached to the wax, and an outer mold formed around the wax. The wax is melted out, and the molten metal cast-in to complete the missing element. Often, cast-in repairs are not visible on the surface, owing to a good alloy match, to the excellence of the CHASING, or to the presence of a thickly applied surface PATINA.

CENOTAPH See TOMB.

CHASING A term encompassing two processes in metal working: first, the MODELING of decorative patterns on a hand-shaped sheet-metal surface using PUNCHES applied to the front, usually in combi-

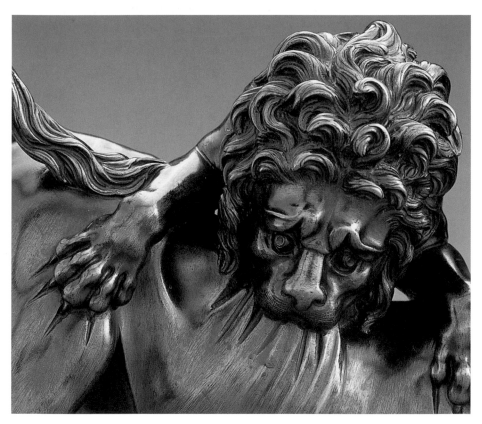

CHASING

Antonio Susini (Italian, active 1572–1624) or Giovanni Francesco Susini (Italian, 1585–c. 1653) after a model by Giambologna (1529–1608). *Lion Attacking a Bull* (detail), first quarter of the 17th century. Bronze, H: 20.3 cm (8 in.). JPGM, 94.SB.11.2.

Meticulous CHASING of the cast bronze surface includes fine chisel work in the mane, eyes, and claws to delineate and sharpen details; texturing in the muzzle to indicate whiskers; and fine scratch brushing on the back of the bull to suggest the texture of the hide and to impart a luster to the patinated surface.

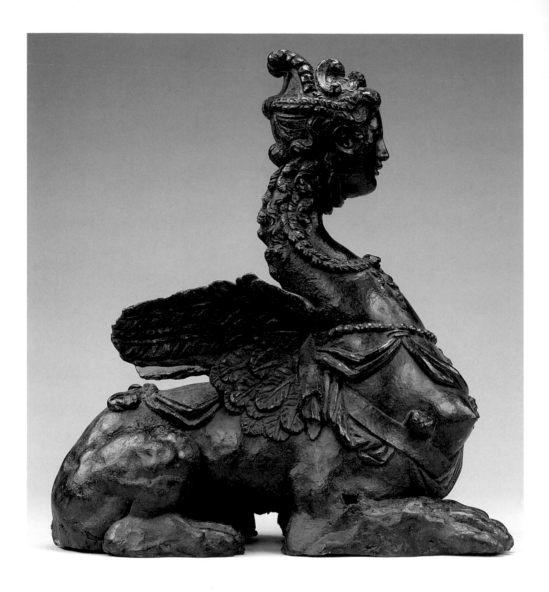

CHASING

Sphinx, Italian, c. 1570. Bronze, H: 65 cm (25⅝ in.); W: 25 cm (9¹³/₁₆ in.); D: 56 cm (22⁵/₁₆ in.).
JPGM, 85.SB.418.2.

In the process of CHASING this bronze, the surface was hammered overall. Casting flaws were
plugged with bronze; a rectangular plug on the right forepaw has fallen out, leaving a hole.

nation with *repoussé*, a technique in which the back is hammered to create a raised relief on the front; and second, the finishing and refinement of a cast sculpture. The initial stage of chasing a cast bronze sculpture is sometimes called FETTLING, which includes scrubbing the surface to remove the black oxide layer, as well as removing the SPRUES and vents, and the *fins* or *flashes* resulting from cracks and joins in the mold, by sawing, filing, and chiseling. The CORE, CORE PINS, and ARMATURE are often removed if possible, the core pin holes and casting flaws are filled with PLUGS or CAST-IN REPAIRS, and separately cast elements are joined together. The next chasing step involves finer tooling of the surface, including: hammering to hide added plugs and repairs; sharpening or adding details using chisels and punches; wire brushing to give an even, light-catching striation to the surface; and polishing in selected areas using a variety of abrasives, scrapers, or burnishers (see PUNCHING and BURNISHING). The chasing of a sculpture requires tremendous skill and time, and its level of quality varies greatly with each artist.

CIRE PERDUE
(FRENCH, "LOST WAX")

See LOST WAX CASTING.

CLAY

A natural material formed by the decomposition of certain types of rock. When mixed with water, it becomes a stiff paste that can be shaped and then fired (exposed to intense heat) so that the form hardens. Its availability and malleability make it a common sculpting material. Composed primarily of hydrated aluminum silicate crystals, clay may also contain sand, feldspar, mica, iron oxides, calcium carbonate, and organic materials. The mixture of components varies from deposit to deposit, and thus clays vary greatly in color and texture as well as in workability and in how they react to firing. The color of fired clay is primarily determined by its composition and the conditions under which it is fired. A clay that does not contain iron will be white after firing, while one that contains a mixture of iron and calcium will be buff or yellow. Shades of red, brown, or black can be achieved by varying the amount of iron compounds and the firing conditions (for example, the temperature and the availability or lack of oxygen). When wet, clay is soft and easily manipulated, but it becomes brittle and fragile when dry (see TERRA-CRUDA). It is possible to adjust the composition of the clay in order to change certain properties. For example, to prevent cracking and excessive shrinkage during firing, *grog* (ground up fired clay) or sand can be added to the clay. In order to lower the cost and risks of production, compounds called *fluxes*, such as calcium carbonate,

iron oxide, or feldspar, can be added to the clay to lower the firing temperature.

Clay can be PRESS MOLDED, SLIP CAST, or MODELED freehand. Mold-made sculpture can be removed from the mold while still slightly damp, which allows the surface to be further manipulated by CARVING, texturing, and BURNISHING. This capability allows for some degree of variety within a series, or EDITION, of mold-made clay copies. Modeled compositions are built up as solid clay forms, with or without an ARMATURE. Most solid sculptures are cut open and hollowed out to create walls of a consistent depth; this ensures even shrinkage and reduces or avoids cracking, which can occur during drying and firing. Hollow sculptures are either laid on their sides with the opening in the bottom exposed or vent holes are cut into the side to allow expanding air to escape during firing. Firing or baking dry clay converts it into the more durable TERRA-COTTA.

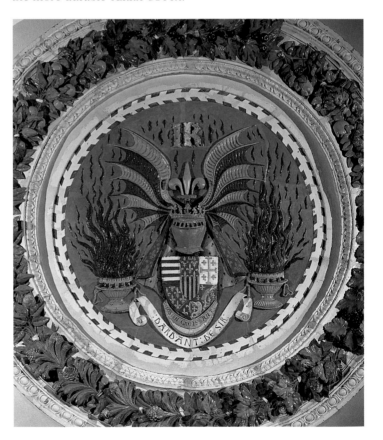

COAT OF ARMS

Luca della Robbia (Italian, 1399/1400–1482). *Coat of arms of René of Anjou* (detail), c. 1466–78. Glazed terra-cotta, Diam: 335 cm (11 ft). V&A, 651–1865.

This round relief depicts the COAT OF ARMS of René of Anjou (1409–1480), surmounted by a crowned helmet with a fleur-de-lys between a pair of dragon wings. Behind the helmet and shield is a cloak, or mantle, decorated with the gold Anjou fleur-de-lys on blue. At either side is another emblem common to René, a flaming brazier. The various heraldic elements of the composition, including the written initials and phrases, all refer to René and/or one of his many titles: Duke of Anjou and Count of Provence; Duke of Bar; Duke of Lorraine; titular King of Naples and Sicily, Hungary, and Jerusalem; and Pretender to the Crown of Aragon.

Coat of arms

A heraldic device identifying an individual's family and/or lineage. Coats of arms can establish an individual's office as well as his or her heritage. For instance, the coat of arms of a pope may include the papal tiara and keys of Saint Peter in addition to a family emblem.

Colossus

A statue of extraordinary size, usually two to three times the standard or ideal height of a man. The term was first used exclusively to designate sculpture of this scale in the fourth century B.C. Its meaning was revived in sixteenth-century Italy, where sculptors produced more colossal statues or groups than in any other century since antiquity.

Conservation

All actions aimed at safeguarding cultural property for the future. The purpose of conservation is to study, record, retain, and restore the culturally significant qualities of an object with the least possible intervention. A conservation professional, or conservator, is an individual whose primary occupation is the preservation of cultural property in accordance with the Code of Ethics and Guidelines for Practice established for the country in which the conservator works. Modern conservation may include restoration—the replacement of missing parts—but it places an emphasis on retention of original material and on the preventive aspects of collections care, including the use of materials and techniques that will not cause further damage to the work of art. Reversible repair materials that can easily be removed are favored as much as is practically possible.

Contrapposto

An Italian term, originating from the Latin *contrapositum* , meaning "placed opposite," and synonymous with *antithesis*, or the juxtaposition of opposites. In sculpture, *contrapposto* usually refers to a stance in which each straight or weight-bearing limb of a standing human figure is juxtaposed with a bent or resting limb to create a diagonal shift in the torso. The resulting asymmetrical distribution of weight in the figure, which approximates the natural disposition of a body at rest, imbues the sculpture with a sense of lifelikeness and movement. The asymmetry of *contrapposto* occurs primarily in a single plane and is therefore distinct from the related compositional device of FIGURA SER-PENTINATA, which involves a twist in three dimensions. In the Renaissance, the term *contrapposto* was also applied to contrasting elements within a painted or sculpted composition. The juxtaposition of a male and female figure, of a young boy and an old

man, and of a figure seen from the front and one seen from the back, are all examples of *contrapposto* in this more general sense. Such contrasts were thought to heighten the viewer's delight in a work of art by creating variety, a quality associated in the Renaissance with beauty.

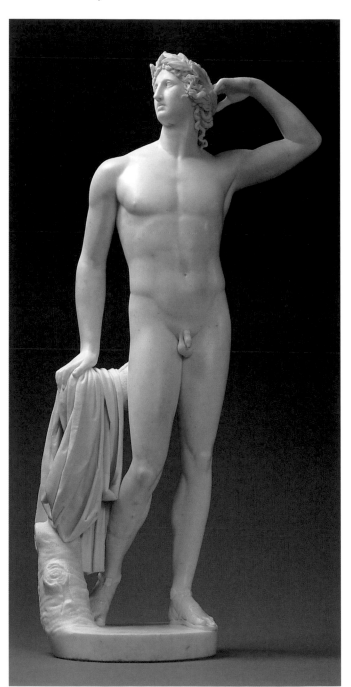

CONTRAPPOSTO

Antonio Canova (Italian, 1757–1822). *Apollo*, 1781–2. Marble, H: 84.7 cm (33⅜ in.). JPGM, 95.SA.71.

The CONTRAPPOSTO stance of Canova's male nude figure is achieved by the juxtaposition of his straight, weight-bearing left leg with his bent, resting right leg and the left leg's placement diagonally opposite his straight right arm.

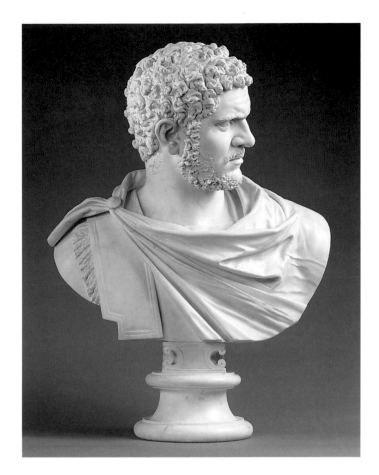

COPY

Bartolomeo Cavaceppi
(Italian, 1716/17–1799).
Bust of Emperor Caracalla,
c. 1750–70. Marble,
H: 71.1 cm (28 in.).
JPGM, 94.SA.46.

This sculpture is a faithful
COPY of a bust in the
National Archeological
Museum in Naples that was
famous in Cavaceppi's time
as one of the most dramatic
portraits from the ancient
Roman empire.

COPY

A more or less exact reproduction of an existing sculpture. His-
torically, the term was associated with common workshop prac-
tices and did not bear its present-day pejorative implications. For
instance, copies or REDUCTIONS of ancient works of art were exe-
cuted by some of the most skillful European sculptors from the
Renaissance on and were valued by collectors and antiquarians.
Artists produced copies of their own work for different clients or
supervised the copying of their sculptures by studio assistants.
Patrons unable to obtain an original work from a particular sculp-
tor might commission a copy of the work from a different artist.
Copies were usually produced without the intent to deceive. A
reproduction that was deliberately made to deceive collectors or
potential buyers is more accurately termed a *fake* or *forgery*.

CORE

The material that fills the interior cavity of a MOLD when a hollow
metal casting is made. The core must be made of a *refractory*
material, that is, one which will resist high temperatures without

melting, burning, excessive shrinking, or cracking. A core is used in both the LOST WAX and SAND CASTING techniques for all but the smallest of sculptures. The core's size in relation to the outer mold determines the final thickness of the cast metal. One of the primary functions of the core is to reduce the amount of metal in the cast and thus reduce its cost. The other is to keep the walls of the cast uniform in thickness to help avoid extreme or uneven shrinkage or distortion. The core also absorbs vapors that result from the molten metal coming in contact with organic residues or traces of moisture remaining in the mold, thereby reducing the occurrence of trapped gas bubbles that weaken the metal and can cause surface blemishes. In sand casting and direct lost wax casting, the core is often built around an ARMATURE, which acts as an internal support. In the indirect lost wax method, the core is poured into the molded hollow wax shell and allowed to harden. The core and armature are often removed once the bronze is cast, possibly to lessen the weight of the finished sculpture. On outdoor sculpture, the core and iron armature are generally removed in order to avoid damage from absorption of water.

CORE PINS

Venus and Cupid (detail), French or Italian, c. 1550. Bronze, H: 98 cm (35 in.). JPGM, 87.SB.50.

The darkened spot in Venus's cheek is from an iron CORE PIN that was pushed part way into the interior.

CORE PINS

Pins or rods (also called *chaplets*) used in metal casting to hold the CORE in correct alignment to the outer MOLD, preserving the space between the two and thus defining the thickness of the metal. Core pins are usually made of iron, which resists melting when molten bronze is poured into the mold in LOST WAX CASTING. Core pins are often, but not always, removed from the finished cast by pushing them into its hollow interior (see PLUG). Core pins not removed during CHASING can sometimes be detected on the sculpture's surface as dark, rust-colored magnetic spots. See LOST WAX CASTING.

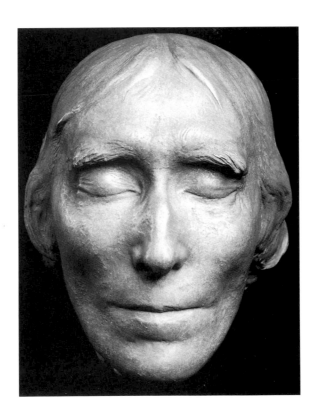

DEATH MASK

Sir George Frampton (British, 1860–1928). *Death Mask of Sir Henry Irving,* 1905. Gilded plaster, H: 21.6 cm (8½ in.); W: 7.8 cm (7 in.); D: 16.5 cm (6½ in.). V&A, A.20–1932.

The closed eyes and tight, drawn features of this famous 19th-century actor's face are characteristic of a DEATH MASK.

DEATH MASK

An impression or MOLD of the face of a deceased person, usually made by oiling the skin and taking a plaster cast of the features. A death mask could serve as the basis for a TOMB effigy, and later as the MODEL for additional portraits, because it so accurately recorded the features of the deceased subject. In a *life mask* or LIFE CAST, a plaster cast is made from the face of a living subject. Molds of other parts of the body, such as the hands, are sometimes made as reference tools for the sculpting of full-length figures.

The creation of a hole using a tool called a drill which contains an edged or pointed tip that is rotated to remove material. Very simple drills rotated by hand, such as an awl or auger, can be used for cutting WOOD or IVORY. Drills used since antiquity for stone and wood include the *cord* or *strap drill*, and the *pump drill*. The *brace and bit drill* was introduced in the sixteenth century. The cord drill is sometimes called a *running drill* as it can be used in marble carving to create long, shallow, "running" channels. A drill was used for cutting deep channels in MARBLE by drilling a line of distinct holes which could then be connected by chiseling out the marble between them. The drill is often used to create surface texture, dramatically setting dark shadows against the white marble surface. Because it relies on smooth and controlled cutting motions, rather than the percussive motion of carving with a hammer and chisel, the drill can be used to create delicately projecting forms in marble. Although large mechanized drill presses were available in the nineteenth century, it was not until the twentieth century that hand-held rotary drills became available.

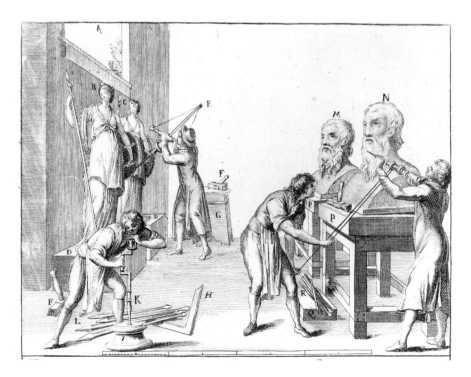

DRILLING

Three types of drills are illustrated in this engraving from an instructional manual: (E) a pump drill, (K) a brace and bit drill, and (O) a strap drill with a shoulder brace. (From *Istruzione per gli studiosi della scultura* by Francesco Carradori [Florence, 1802], pl. XII.)

DRILLING

Gian Lorenzo Bernini
(Italian, 1598–1680).
Bust of Thomas Baker,
c. 1637–39. Marble,
H: 81.6 cm (32½ in.).
V&A, A.63–1921.

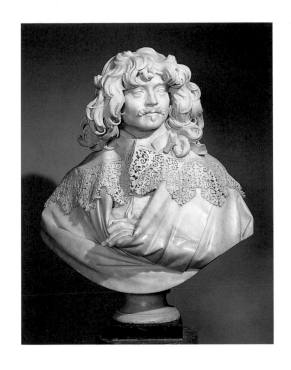

A drill was used extensively
to render the lace and parts
of the hair in the portrait
bust above.

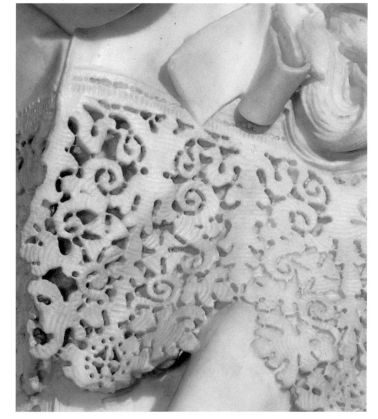

ÉBAUCHE

Paul Egell (German, 1691–
1752). *Saint Francis Borgia*,
c. 1750. Wood, H (without
base): 23.8 cm (9⅜ in.).
V&A, A.5–1911.

The rough, angular surface
and lack of detail on this
wooden carving indicate that
it was never finished and is
therefore an ÉBAUCHE.

Ébauche

(French, "rough draft")

A stage in the development of a finished sculpture, usually of
stone or wood, in which the basic forms, volumes, and essential
elements of the composition have been established, but the
details have not been carved and the surface is rough and unpol-
ished. The term *ébauche* signifies an unfinished sculpture, at a
preliminary stage of its execution. It should not be confused
with a preparatory study for a sculpture. Compare MODEL.

ÉCORCHÉ

(FRENCH, "FLAYED," "PEELED")

A sculpture representing a human figure or an animal in which the skin has been stripped off to reveal the muscles, tendons, arteries, and veins. Such representations were used as anatomical reference tools, illustrating the correct forms and relationships of the various muscle groups. *Écorché* figures should not be confused with portrayals of Saint Bartholomew, whose flayed skin serves as an ATTRIBUTE of his martyrdom.

ÉCORCHÉ
After Ludovico Cigoli
(Italian, 1559–1613).
Anatomical Figure, 17th
century. Bronze, H: 62 cm
(24 ⅜ in.). V&A, A.25–1956.

EDITION	The intentional production of a sculpture in several virtually identical examples. In sculpture, the term *edition* is usually associated with bronze casting and signifies the execution of multiple casts from the same set of MOLDS, which derive from the original MODEL. The resulting bronzes, sometimes called *replicas*, are substantially the same in size, form, and composition. The repeated use of the same molds ensures consistency among the bronzes in the edition, but slight variations occur due to casting flaws, to differences in CHASING (if the finishing of each bronze is entrusted to a different foundry assistant), or to deterioration of the molds. An edition is usually limited to a certain number of casts; the size of an edition may be determined by either the artist or the foundry, depending upon the nature and purpose of the commission. Although multiple casts of bronzes were executed as early as the late fifteenth century, the widespread production of bronzes in large editions began in the nineteenth century.
EFFIGY	See TOMB.
ELECTROPLATING	The process of applying a metal coating to a surface by means of an electric current. The surface to be coated is submerged in a bath containing an electrolyte solution and a solid piece of the plating metal. An electric current is applied to the bath, causing the plating metal to dissolve and deposit onto the surface to be coated. That surface must be electrically conductive; it can be metal or a material such as wood, plaster, or wax that has been made conductive by coating it with graphite or a metallic powder. Although pure metals such as silver, gold, and copper are most easily deposited, electroplating ALLOYS such as brass is also possible. Since they are difficult to chemically patinate, electroplated surfaces are frequently coated with colored lacquers (see PATINA). Electroplating was discovered in the early nineteenth century and came into common use in the 1840s.
ELECTROTYPING	The process of using an electric current to deposit metal into a mold or negative impression of a desired form, in order to create a three-dimensional relief. A similar technique, *electroforming*, builds a metal shell onto a positive pattern. The mold or pattern can be made of wax or plaster coated with an electrically conductive material such as graphite. The process is similar to ELECTROPLATING, but with different results, since electrotyping creates a metal shell rather than a surface coating. Electrotypes were often backed with other metals such as lead to strengthen the shell and make them as heavy as a cast sculpture. An electrotype is sometimes distinguishable from a LOST WAX or SAND CAST sculpture by

its very even and often thin walls. An electrotype made of a less expensive material, like copper, can be electroplated with silver or gold to give the impression of a solid silver or gold casting. Electrotyping was developed in the mid-nineteenth century and gave rise to the mass production of affordable works of art and decoration for the general public.

ENLARGEMENT

A reproduction of an existing sculpture on a larger scale. See REDUCTION.

EQUESTRIAN

An adjective describing the image, often a PORTRAIT, of a person on horseback. The equestrian portrait monument in European sculpture derived from ancient Roman precedents and was

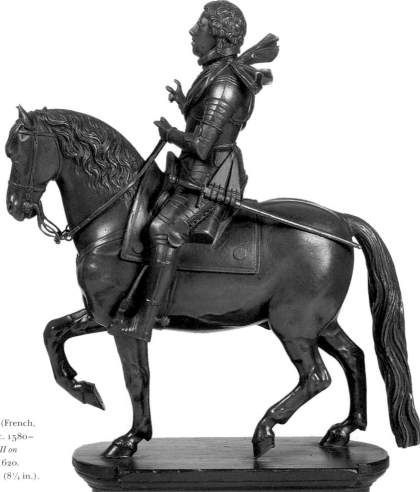

EQUESTRIAN
Hubert Le Sueur (French, active in Britain, c. 1580–c. 1670). *Louis XIII on Horseback*, about 1620. Bronze, H: 21 cm (8¼ in.). V&A, A.1–1994.

intended to evoke the glory and power of the Roman empire. This sculptural genre was, therefore, extremely popular for the representation of military leaders and rulers. For technical reasons large equestrian monuments were usually executed in bronze rather than stone: the tensile strength and lighter weight of a hollow-cast bronze allowed the sculptor to show the horse rearing or prancing on two or three legs without the need for additional SUPPORTS. See BRONZE.

Esquisse

See SKETCH and MODEL.

Estofado

See SGRAFFITO.

Facture

The manner in which a work of sculpture is executed and its material manipulated to achieve a desired appearance. The term *facture* refers to the distinct characteristics of a sculpture's details, execution, and surface that distinguish it as the work of a particular artist, school, period, or place of origin.

Fettling

To trim or clean away unwanted mold seams or rough edges from the surface of a sculpture cast in terra-cotta, plaster, wax, or, sometimes, metal. See CHASING and MOLD.

Figura serpentinata

An Italian term describing the pose of a figure whose twisting form creates a serpentine or spiral curve. *Figura serpentinata* approximates the motion of a flame, which spirals upward while maintaining its contours. It is an extension of CONTRAPPOSTO. In *contrapposto* the shift of the torso occurs primarily in one plane, whereas *figura serpentinata* requires the body to turn in space around a central axis. Often the torsion of the pose is sufficiently exaggerated to display parts of both the front and the back of the human figure from a single point of view. For instance, a stationary male figure twisting to his right might expose the back of his left shoulder and the front of his abdomen when viewed head-on. *Figura serpentinata* can be thought of as a compositional device that maximizes the impression of motion in a figure with a minimum of locomotion.

FIGURA SERPENTINATA

Attributed to Tiziano Aspetti
(Italian, c. 1559–1606).
Nude Male Figure, c. 1600.
Bronze, H: 75 cm (29½ in.).
JPGM, 88.SB.115.

The figure's twisting pose,
which seems to conform to
an upward spiral, is an
example of FIGURA
SERPENTINATA.

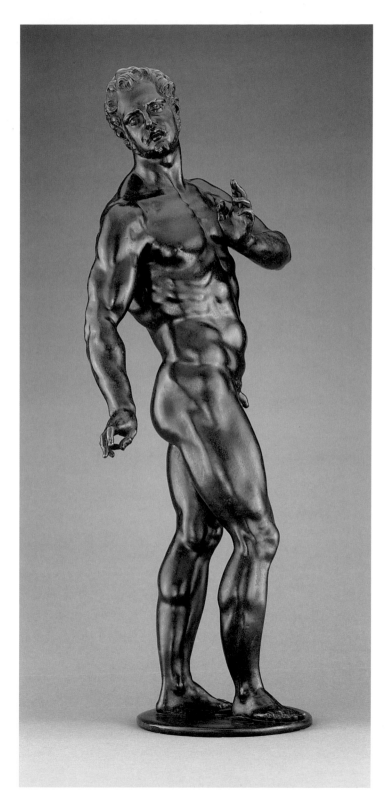

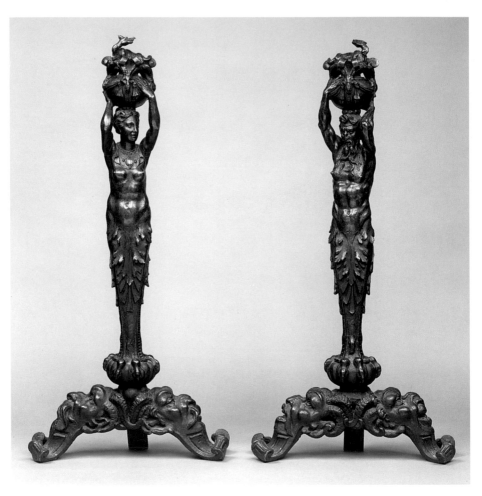

FIREDOGS

Italian artist working at Fontainebleau. *Pair of Firedogs*, c. 1540–45. Bronze, H (of each): 82.5 cm (33½ in.). JPGM, 94.SB.77.1–.2.

FIREDOGS

A pair of metal supports for firewood placed in a hearth, consisting of a horizontal bar on short legs that supports the wood and a vertical shaft at the front that rests on either short legs or a stable base. Originally firedogs, also called *andirons*, were geometric in design, but by the mid-sixteenth century their vertical shafts were ornamented with figural and other decorative elements. Intended to flank the fire, firedogs are usually symmetrical to each other in shape or, in the case of figural andirons, mirror each other in pose. The decorative elements of andirons were often chosen for their associations with the element of Fire.

FIRING CRACKS
Joseph Chinard (French, 1756–1813). *Family of General Duhesme* (back view), c. 1808.
Terra-cotta, H: 56 cm (22¹⁄₁₆ in.); L: 70 cm (27⁹⁄₁₆ in.); D: 35 cm (13¾ in.). JPGM, 85.SC.82.

This back view of the sculpture illustrated under MEDALLION displays the long cracks that formed during firing.

FIRING CRACKS

Cracks formed in ceramic sculpture during firing (see TERRA-COTTA). Cracks form when ceramics are heated too quickly, often appearing in areas where *drying cracks* have already occurred. Drying cracks are caused when the clay shrinks unevenly or as a result of weak areas that can occur where portions of clay were joined in MODELING.

FOUNDRY

The establishment where metal casting takes place. A LOST WAX foundry is divided into areas where the various functions are performed: a MOLD and wax making area; the casting area with a KILN or drying oven, a melting furnace (in which metals are melted and ALLOYED), and a casting pit; and a CHASING and PATI-NATION area. Because of the expense and experience needed to

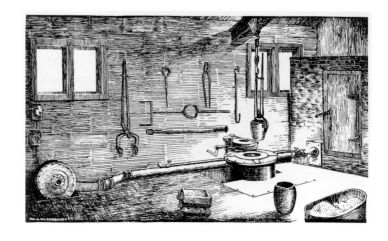

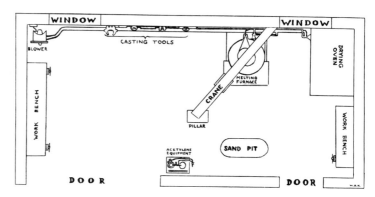

Foundry

Although the twentieth-century FOUNDRY shown here is run by electricity, the basic elements are similar to those found in earlier foundries, including: a drying oven where the MOLDS are dried and the wax is melted out; the sand pit where the molds are buried; a furnace for melting the metals; and a crane for transporting and pouring the molten metal. ("Small bronze foundry at the Stella Elkins Tyler Fine Arts School" from *Sculpture Inside and Out* by Malvina Hoffman [New York, 1939], fig. 254.)

run a foundry, as well as local guild restrictions, artists often entrusted the casting of their models to professional founders rather than establishing foundries within their own workshops.

Foundry stamp

Foundry stamp
Antoine-Louis Barye (French, 1796–1875). *Elephant of Senegal* (detail), c. 1880. Bronze, H: 14 cm (5½ in.); L: 19 cm (7½ in.). V&A, 62–1882 (S.Ex).

This detail of the bronze illustrated under ANIMALIER shows the gold stamp of the Paris founder Ferdinand Barbedienne (French, 1810–1892).

A general term describing identification marks added to a cast sculpture by the FOUNDRY. Foundry stamps may indicate the

name of the foundry or founder, the date of execution, and/or the EDITION number. The stamp may be pressed or carved into the wax MODEL or the CORE before casting or incised or stamped into the cast metal itself.

FRONTAL

Joseph Nollekens (British, 1737–1823). *Castor and Pollux*, 1767. Marble, H: 160.7 cm (5 ft. 3 ¾ in.). V&A, A.59–1940.

FRONTAL

A descriptive term for a sculpture strongly oriented toward a single viewpoint, which is obtained by standing directly in front of the work. In a frontal sculpture, the view from the front is always the PRIMARY VIEW. The frontality of a work may reflect its intended setting, such as a deep NICHE, in which the back and profile cannot be seen by the viewer. The frontal alignment of such sculptures may convey a sense of stasis or rigidity. Compare MULTIPLE VIEWS.

GESSO

(ITALIAN, "GYPSUM")

In Italian, the word *gesso* refers to calcium sulfate, in both its simple form as powdered gypsum rock and as GYPSUM PLASTER. In English the term *gesso* refers to a white paste used as a preparation layer in the decoration of rough and porous materials such as stone, wood, and terra-cotta. The paste is made by mixing an animal glue with either *gypsum* (calcium sulfate/ $CaSO_4$) or *chalk*, also referred to as *whiting* (calcium carbonate/ $CaCO_3$). The mineral used in preparing gesso is usually determined by which material is available locally. Generally speaking, gypsum is found in gesso from Italy and southern European countries, and chalk occurs in British and northern European gesso. Before the gesso is applied, the porous surface is sealed with a water soluble glue. Gesso is then brushed on in layers, and the final layer is carefully smoothed or carved with carving tools or scrapers (a process called *recutting*) in preparation for decoration or GILDING.

GILDING

The process of coating an object with a thin layer of gold. A surface which has been covered by gilding is said to be *gilt* or *gilded*. The term applies to a variety of techniques and is sometimes used in reference to other coatings meant to imitate gold, such as silver leaf, tin leaf, or palladium leaf (a nontarnishing silver-colored metal) coated with gold-colored GLAZES; Dutch metal (brass leaf, also called *schlag* leaf and composition leaf); and "gold powders" made of gold-colored brass (see BRONZING). As a decorative technique, the purpose of gilding is to create illusionistic effects. A sculpture that is completely gilded appears to be solid gold, while a partially gilded surface can imitate the appearance of other textures and materials (see SGRAFFITO). The term *parcel gilt* refers to partial gilding of selected elements. When silver leaf is employed for its own sake rather than to imitate gold, the term used is *silver gilt*, or *silvering*.

The three primary European techniques for applying gold to sculpture were leaf gilding, mercury gilding, and, after the mid-eighteenth century, ELECTROPLATING. Gold leaf is gold that has been hammered into sheets so thin they cannot be touched but must be handled with special tools. Leaf gilding is the application of gold leaf by means of one of two processes: water gilding and mordant gilding. In *water gilding*, the rough surface of the sculpture is sealed with animal glue and leveled by application of a GESSO ground. A *bole* layer composed of colored clay (usually red or yellow) and a water-based glue is then brushed over the gesso, allowed to dry, and carefully smoothed. The bole is then dampened, which activates the glue, and gold leaf is applied. Water gilding can be BURNISHED to achieve a mirrorlike polish or left matte. In *mordant gilding*, also called *oil gilding*, a gesso prepara-

GILDING

Pier Jacopo Alari-Bonacolsi,
called Antico (Italian,
c. 1460–1528). *Meleager*,
late 15th century. Bronze,
partially gilt, with silver eyes,
H: 30.8 cm (12⅛ in.).
V&A, A.27–1960.

On this parcel gilt bronze
figure, the hair, beard,
drapery, and sandals were
coated with gold by means
of mercury GILDING.

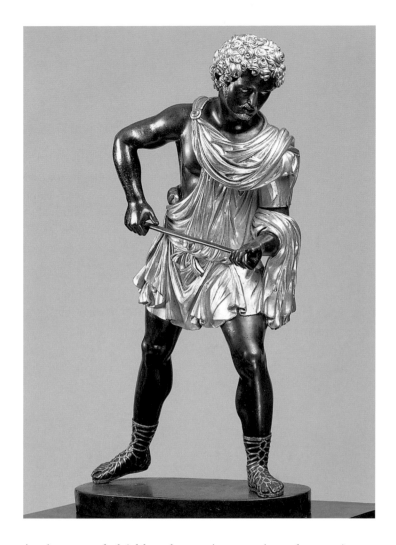

tion is not needed (although sometimes one is used anyway).
Porous surfaces such as stone and terra-cotta must be sealed
with a coating over which an oil-based adhesive (called the *size*)
is applied with a brush. Gold leaf is adhered to the size when it is
almost dry but still tacky. Mordant gilding is less time-consuming
than water gilding, but it cannot be burnished, resulting in a
more matte surface. Sometimes the two techniques are combined
to give added visual contrast. Both mordant- and water-gilded
surfaces can be further embellished with translucent colored
glazes. *Mercury gilding*—also called *fire gilding* or *amalgam
gilding*—is a technique for gilding metals. It involves dissolving
gold in mercury to form a paste (*amalgam*) which is then applied
to the metal sculpture (usually silver, brass, and other copper
ALLOYS) using a wire brush. The sculpture is heated, and the
amalgam melds with the underlying metal as most of the mercury

evaporates. The remaining gold is then burnished to a high polish or colored further with a variety of chemicals or coatings. Mercury gilding can also be achieved using sheets of gold leaf by applying mercury directly to brass or silver, laying on the gold leaf, and heating. The health risks posed by mercury vapor were well known and explain the decline of mercury gilding after electroplating was introduced in Europe in the 1840s.

GLAZE

Girolamo della Robbia (Italian, 1488–1566). *Bust of a Man*, 1526–35. Glazed terra-cotta, H: 46.4 cm (18¼ in.). JPGM, 95.SC.21.

The Florentine della Robbia family was famous for their use of GLAZED terra-cotta for sculpture and architectural decoration.

GLAZE

In ceramic sculpture, a silica-based glassy coating fused to a ceramic body, which functions as both a decorative and a protective layer. In other polychrome sculpture, a colored transparent layer of resin applied over metal leaf or a painted surface (see GILDING). Glazing over silver leaf could be used to give the appearance of gold or gemstones; in addition, the resin protects the silver leaf from tarnishing. Glazes applied over opaque paint layers lend a luminous quality to the underlying paint. Colorants used for resin glazes include dyes, pigments, and stains.

GRAIN

The distinctive pattern and texture of a material that results from the arrangement, especially the stratification, of its particles or cells. The characteristic grains of wood, ivory, and stone influence both their appearance and the way they are carved. Each type of WOOD has a distinctive grain and coloration, which can vary within a particular piece, lending a variety of patterns and colors to the carved surface. Because the fibers that give wood its grain lie mostly parallel along its length, wood has greater strength lengthwise than crosswise. Each type of IVORY also has a distinctive grain, but because the grain is very fine, it is difficult to see in many finished carvings. *Grain* also refers to the presence of colored patterns in stone, as well as to the size of the individual crystals of which the stone is composed. Because stone is composed of crystals rather than long fibers, it is inherently weak when carved into thin projections. In LIMESTONE and many SANDSTONES, the direction of the grain is visible as horizontal *bedding lines* that were created as the stone was formed. Stone breaks more easily along the grain and is often more difficult to carve across the grain. The term *grain* is also used in technical descriptions to designate discrete particles of material in fired or unfired CLAY and to indicate individual crystals in metals.

GYPSUM PLASTER

A white powdery substance which, when mixed with water, sets through crystallization to a hard, brittle solid. Gypsum plaster is also known as plaster of Paris (calcium sulfate hemihydrate/ $CaSO_4 \cdot \frac{1}{2} H_2O$ before it is mixed with water and calcium sulfate dihydrate/$CaSO_4 \cdot 2H_2O$ after setting), and was so named because there are large deposits of gypsum below that city. Gypsum plaster is made from gypsum rock that has been baked at temperatures less than 400 degrees Centigrade, to remove some of the chemically bound water, and then ground to a powder. Gypsum plaster is relatively inexpensive, fine-textured, easily mixed and applied, and relatively quick-setting. It is an ideal MOLD-making material, as it flows easily into voids and, while setting, undergoes a process of crystallization that causes a slight expansion, forcing the plaster into the fine details of the mold. When used as a mold material for casting CLAY, the porous plaster absorbs excess moisture, speeding the drying process. Gypsum plaster molds are used to produce sculpture or decorative objects in porcelain, plaster, wax, terra-cotta, and, with the addition of sand, cast metal. Gypsum plaster as a sculpting medium can be poured, pressed, or brushed into molds of wood, clay, plaster, or gelatin, and can be cast solid or hollow (see SLUSH CASTING).

Models made of fragile materials like wax or clay can be cast in plaster and used to create marble sculptures with the

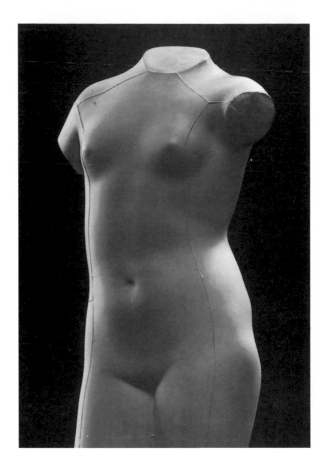

GYPSUM PLASTER

Alphonse Legros (French, active in Britain, 1837–1911). *Female Torso* (detail), 1890. Gypsum plaster, H: 52 cm (20½ in.); W: 19.7 cm (7¾ in.); D: 13.3 cm (5¼ in.). V&A, 378–1891.

The fine raised lines on its surface indicate that this plaster was cast using a piece mold; when mold sections are connected, lines may form along these joins.

POINTING technique. The use of gypsum plaster for reproductions of marble and bronze sculpture became increasingly common in the eighteenth and nineteenth centuries, especially to provide collectors with examples of famous ancient works when the originals could not be obtained. In art schools, these plasters made ancient compositions available to students for studying and copying. In the nineteenth century, artists increasingly produced gypsum plaster reproductions of their own compositions. Many of these plaster reproductions were painted, BRONZED, or GILDED over a layer of animal glue, resins, drying oils, or shellac. Although it is not a common technique, gypsum plaster can be MODELED as well as cast in order to create original, unique works of art. By adding *retardants* such as citric acid or urine, which act to slow the setting time, the plaster can be built up on an ARMATURE and the surface manipulated while still wet. After it has set, the surface can be further worked using rifflers, rasps, sandpaper, etc. Plaster made from limestone, called LIMEPLASTER, is often confused with gypsum plaster, although the two are quite different in their chemical composition, preparation, and use.

HERM

David d'Angers (French,
1788–1856). *Herm Portrait
of Mary Robinson*, 1824.
Marble, H: 46.3 cm (18 ½ in.).
JPGM, 93.SA.56.

HERM

A sculpted figure or bust that terminates—either at the chest or
below the waist—in an abstract blocklike mass. The herm, also
called a *term*, apparently originated in ancient Greece as a large
pile of stones resembling a giant phallus, which was dedicated
to Hermes, the god of travel, and placed along a road as a
marker. It evolved into a sculpted form consisting of a represen-
tational head atop a rectangular pedestal with an erect phallus.
In later Greek art the herm form lost its exclusive association
with Hermes; heads of other male and female deities, famous
personalities, or even ordinary PORTRAIT sitters were given block-
like TERMINATIONS and displayed on rectangular pedestals in
various contexts and settings. The herm was used extensively
in seventeenth-century European garden sculpture for repre-
sentations of classical deities and mythological creatures

of the forest. In late eighteenth- and early nineteenth-century Europe, it enjoyed even more widespread use for portraits and other subjects.

IN SITU

(LATIN, "IN PLACE")

A term applied to works of art that remain in their intended locations and settings. A sculpture's history, function, style, authorship, and meaning may be intimately bound to its original context. Therefore, if a sculpture is removed from its setting, or its physical context is changed or destroyed, much art historical information may be obscured. Most sculptures in museums today, with the exception of many twentieth-century works, are no longer in situ.

INSCRIPTION

Any text that has been cast, carved, engraved, or stamped into a surface, or—in the case of soft materials like clay or wax—formed with a stylus or other pointed tool. Inscriptions on sculpted works of art may include the artist's signature, the date of execution, the artist's country or city of origin, and/or the title of the work. Terms commonly found in conjunction with an artist's signature are: *fecit* (abbreviated *fec.* or *f.*), meaning "he made it"; *faciebat* (abbreviated *facieb.*), meaning "he was making it"; and *sculpsit* (abbreviated *sculp.*, *sculpt.*, or *sc.*), meaning "he carved it." Inscriptions on TOMBS usually include the name of the deceased, his or her date of death, and, sometimes, a commemorative text.

IN-THE-ROUND

A three-dimensional sculpture CARVED or MODELED on all sides. A sculpture is still considered to have been sculpted in-the-round even if the degree of finish is not equal on every side. This condition might occur, for example, if a work was intended to be placed in a NICHE, where some sides would not be visible. Sculpture is described as being conceived or executed in-the-round to distinguish it from RELIEF.

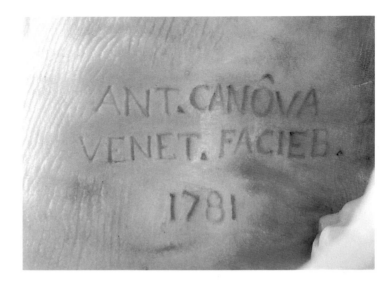

INSCRIPTION

Antonio Canova (Italian, 1757–1822). *Apollo*, 1781–2. Marble, H: 84.7 cm (33⅜ in.). JPGM, 95.SA.71.

This detail of the statue illustrated under CONTRAPPOSTO shows the INSCRIPTION, giving the artist's signature, his city of origin, and the year he executed the sculpture.

INSCRIPTION

Hubert Le Sueur, (French, active in Britain, c. 1580–c. 1670). *Louis XIII on Horseback*, c. 1620. Bronze, H: 21 cm (8¼ in.). V&A, A.1–1994.

This detail of the sculpture illustrated under EQUESTRIAN shows an INSCRIPTION, giving the artist's signature, which was stamped into the bronze of the horse's girth.

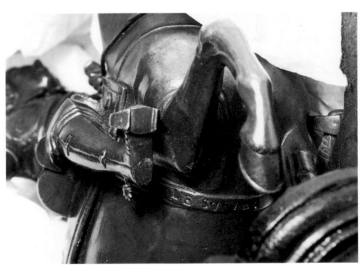

INVESTMENT

The material that makes up the outer mold surrounding the wax model in the LOST WAX CASTING technique. The investment must be composed of a *refractory* material, that is, one which can withstand very high temperatures without melting, burning, excessive shrinking, or cracking. The investment must also resist shrinkage as it dries and must absorb the vapors produced by the contact of hot metal with the mold. Investments are generally composed of sand, *grog* (ground up pieces of previously fired clay), and bits of animal or vegetable fibers bound with clay or plaster. The investment material used for a particular cast may or may not have the same composition as the CORE.

A hard, fine-grained, opaque, off-white material that makes up the bulk of the specialized teeth or tusks of elephants and other large mammals and is primarily composed of a mineral (tricalcium phosphate) and a protein (collagen). Tusks consist of an outer layer, either very tough *cementum*, or hard *enamel*, and a core of *dentine*, which is the part usually used in carving. (Elephant, hippopotamus, and narwhal tusks also have a central hollow or pulp cavity through part of their length.) Although ivory obtained from elephants was generally the most highly prized by carvers because of its size, working characteristics, and translucent creamy white color, they also used tusks from mammoths, walrus, and narwhal, as well as teeth from sperm whale and hippopotamus. Once the enamel and/or cementum are removed,

IVORY

Marcus Heiden (German, active 1618–after 1664). *Covered Standing Cup*, 1631. Turned and carved ivory, H: 63.5 cm (25 in.). JPGM, 91.DH.75.

With the exception of the small infants, or *putti*, and the intricately pierced details, this IVORY cup was formed by turning on a LATHE.

ivory tusks can be used whole, cut into panels for RELIEF carving, or cut into blocks for carving smaller pieces IN-THE-ROUND. In sculpture carved from the whole tusk, the natural curve and taper of the tusk, as well as the internal hollow, strongly dictate the sculptural composition. The very fine, even texture of all ivories allows for highly detailed carving. Tools for working ivory include LATHES, saws, files, rasps, DRILLS, chisels, gouges, gravers, knives, and scrapers, as well as fine abrasives. Ivory was often left unpainted, with only occasional touches of GILDING or POLY-CHROMY. Ivory absorbs and releases moisture in response to changes in humidity, a characteristic that makes it susceptible to cracking and warping.

JOIN

A location on a sculpture where two separate sections have been fitted together. Because artists took great care to hide their joins, join lines are often detectable only through radiography (X-rays). On metal sculpture, separate pieces can be joined mechanically by means of rivets, pins, screws, and dove-tailed joints, or by soldering, welding, or casting adjoining sections in place. (Metal sculptures created using the indirect LOST WAX CASTING technique require fewer metal joins as it is possible to use wax-to-wax joins to attach the separately cast wax sections.) On wood sculpture, woodworking joins such as butt and mortise-and-tenon can be used in combination with glue and nails. The join lines in POLYCHROME wood sculpture were often covered with cloth to obscure the gaps caused when the pieces expanded or contracted in different directions and at different rates.

JOIN

Kaspar Gras (German, 1590–1674). *Kicking Horse,* c. 1630. Bronze, H: 34 cm (13½ in.). JPGM, 85.SB.72.

This radiograph (X-ray) of the bronze illustrated under PATINA reveals the JOINS at the top of the horse's tail and through the center of its belly. Both joins were formed by slipping together and soldering the separately cast sections. For added strength, rivets were added to the join at the belly.

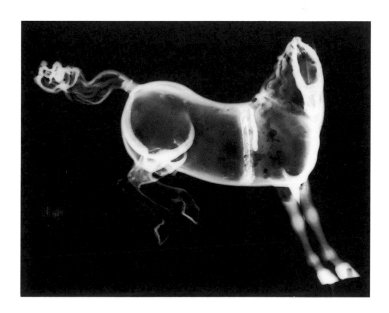

KILN

A brick or stone structure, often located partly underground, that contains a source of heat and a space to place objects. Kilns are used to fire CLAY for TERRA-COTTA sculpture and to prepare MOLDS for metal casting.

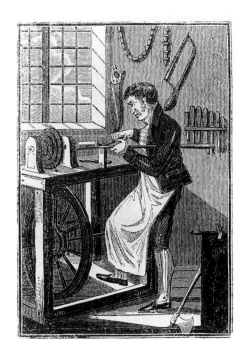

LATHE

A cylinder of wood being turned on a treadle LATHE. ("Turner" from *The Book of English Trades and Library of the Useful Arts* [Printed for C & J Rivington, London, 1827], unnumbered illustration.)

LATHE

A mechanical instrument, known since antiquity, which rotates a piece of material while cutting tools shape it into the desired cylindrical form (a process known as *turning*). Lathes have been used to shape wood and marble SOCLES, ivory goblets, screws, clock parts, and decorative metal forms.

LEAD

A soft, heavy, corrosion-resistant gray metal. Lead is often added as an alloying element in BRONZE and BRASS to decrease the viscosity of the molten metal and make it easier to cast into thin forms. Lead alloyed with tin is used as a solder for metal repairs. Molten lead was sometimes poured into casting flaws to repair bronze sculpture (see illustration for CAST-IN REPAIR) and poured around the iron pins and staples that join stone blocks. Lead can be coldworked by hammering; it is also easily cast, since it has a low melting point and does not stick to iron molds or ladles. For casting, tin or antimony can be added to the lead to make a harder, brighter ALLOY with a lower melting point. Lead can be cast using the LOST WAX or SAND CASTING techniques or,

LEAD

Perhaps by John Cheere
(British, d. 1787).
Alexander Pope, c. 1749.
Lead, H: 47 cm (18⅜ in.).
V&A, A.4–1955.

for large EDITIONS, cast using molds made of bronze. The surface of a cast lead sculpture requires CHASING, often followed by the application of a chemical or resinous PATINA. In the seventeenth century, lead was used extensively for outdoor garden sculpture since, on exposure to air, it forms a protective oxide coating which is resistant to corrosion. However, acid rain due to pollution removes this oxide layer, leaving the lead highly susceptible to damage. Because of its softness and great weight, lead sculpture often suffers from distortion—the form often sinks as the weight settles over time.

LIFE CAST

An image made directly from a living subject or from MOLDS taken from that subject. The term commonly refers to life-size reproductions of organisms, such as plants (e.g., fruits and grasses), small reptiles (e.g., lizards and snakes), insects, and fish, which were made from the specimens themselves. "Life cast" should not be interpreted too literally, since the creatures

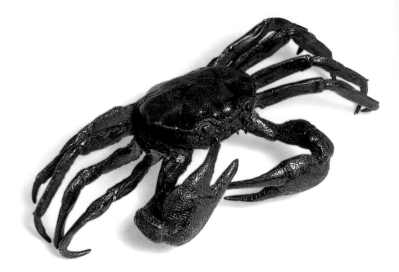

LIFE CAST

Crab, Italian, 16th century.
Bronze, L: 11.1 cm (7⅝ in.);
W: 9.5 cm (3¾ in.).
V&A, A.98–1919.

The realism of this bronze
sea creature is typical of a
LIFE CAST.

would have been killed in order to prepare them for casting or
the taking of molds. The resulting images appear extremely life-
like and accurately record every detail of texture and anatomy.
Historians disagree as to whether the practice of casting from
actual specimens originated in Italy, France, or Germany; the
Italian tradition dates to at least the fourteenth century. In addi-
tion to serving as independent sculptures, specimens cast from
nature frequently decorated metalwork and ceramic plates and
vessels in the sixteenth and seventeenth centuries. Molds of
human anatomy, such as the hands or face, can also be referred
to as life casts when taken directly from a living subject.

LIFE MASK

See DEATH MASK.

LIMEPLASTER

A white powdery substance that when mixed with water sets to a
hard, brittle solid. Limeplaster (calcium carbonate/$CaCO_3$) is
made from limestone that has been pulverized and heated to
approximately 800 degrees Centigrade to convert it into *quicklime*
(calcium oxide/CaO). It is then soaked in water (*slaked*) for an
extended period to produce *lime putty* (calcium hydroxide/
$CaOH$), which is kept in water until ready for use. Limeplaster
sets slowly, in a process that begins with the evaporation of water
followed by the absorption of carbon dioxide (CO_2) from the
atmosphere. Since limeplaster shrinks considerably as it dries,
aggregates such as sand or fibers are sometimes added to reduce
this shrinkage and thereby avoid cracking. Limeplaster can be
MODELED, although it was most often pressed into molds for use
as architectural sculpture and decoration. Limeplaster is often a
primary ingredient of STUCCO and is commonly confused with
GYPSUM PLASTER.

LIMESTONE

A sedimentary stone primarily composed of calcium carbonate (calcite/CaCO$_3$). Other minerals commonly found in varying proportion in limestones include clay, quartz, iron-bearing minerals, and dolomite (calcium magnesium carbonate/ CaMg(CO$_3$)$_2$). Nearly pure calcite limestones are white; other colors, including gray, yellow, buff, red, brown, green, and black, are the result of varying mineral inclusions. Limestone's fine GRAIN permits very detailed carving, but only very hard limestones with a low clay content can be polished. Limestones that can be polished are often called MARBLES owing to traditions which predate modern geological nomenclature. Limestone is finer grained and softer than marble and is likely to contain visible fossils. Limestone is carved in a manner similar to marble, but it is generally more susceptible to damage from improper handling and airborne pollutants.

LIMESTONE

Girolamo Campagna (Italian, 1549/50–1625). *Virgin and Child*, 1578. Istrian stone, H (with stone base): 118.7 cm (3 ft. 10¾ in.). V&A, A.15–1961.

A gray uniformly colored LIMESTONE, Istrian stone was used extensively in Venice and surrounding areas for architecture as well as sculpture.

LOST WAX CASTING

Steps in the indirect lost wax casting technique: (A) a model is made in clay or wax; (B) a hollow wax casting model is made using piece molds taken from the model, and core material is poured in; (C) sprues and core pins are added and the model is invested, at which time (1) metal core pins are driven through the wax into the core, (2) wax sprues, vents, and a casting cup are added, and (3) the entire assemblage is then covered with investment; (D) the entire mold is turned upside down and heated to drive off excess moisture and melt out the wax; (E) the molten metal is poured into the mold cavity through the pouring cup, filling the hollow spaces left by the wax; (F) the investment is knocked away; (G) chasing is done; (H) using sprue ends, the finished bronze is secured to a separately cast base. (Computer graphic by F. Bewer.)

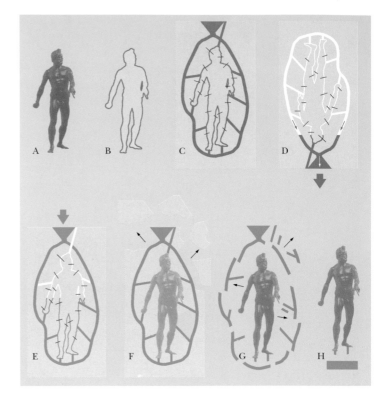

The lost wax casting technique (from left to right): the red wax model; the disassembled white plaster piece mold sections used to make the wax model; the wax model with core pins, sprues, and vents added; the first brush-applied coating of investment; the model fully invested; the cast bronze with attached sprue system and pouring cup (below the feet as the sculpture was cast upside-down); the fully chased and patinated bronze; the bronze in the initial chasing stages. (Photograph courtesy of the V & A.)

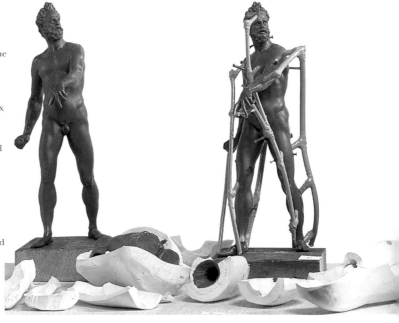

A technique that since antiquity, except for a period in the nineteenth century, has been the primary method for casting BRONZE sculpture. In basic terms, lost wax casting involves replacement of a wax MODEL with molten bronze. When creating waxes for hollow casts, the WAX can be formed in two ways: in the *direct* method, the wax is modeled directly onto a preformed CORE; in the *indirect* method, the wax is pressed or poured into a piece MOLD made from the original model (thus created indirectly), and the core material is then poured into the formed wax. Once the core-filled wax model has been completed by either the direct or indirect method, CORE PINS are driven through the wax into the core and left projecting so that they will engage the outer part of the mold (the INVESTMENT) and preserve the distance between the core and outer mold once the wax is gone. A circulatory system of channels made of wax is then added: SPRUES (or *gates*) to conduct metal into the mold cavity and *vents* (or *risers*) to conduct air and gases out of the mold cavity and core.

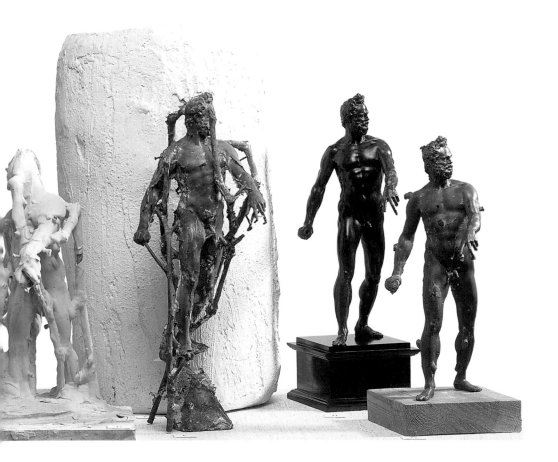

The sprued wax is then enclosed within the investment. The entire assemblage of core, wax model, and outer investment are heated to evaporate all moisture and to melt out the wax. The casting ALLOY is heated and poured into the mold, filling the spaces once occupied by the wax. When the metal has cooled, the cast sculpture is revealed by breaking away the investment. At this point, CHASING and the application of the PATINA can be carried out. Lost wax casts are distinct from SAND CASTS in that their cast-in surface details are finer, and they are less likely to consist of separate sections that were joined after casting. The interior may show the impression of fingerprints or drips that were present in the wax. Lost wax castings are generally more porous than sand castings because the core and investment material do not as readily absorb the released gases, which remain within the metal as bubbles that appear in radiographs (X-rays) as irregularly shaped voids.

LUTING

A method for joining two sections of unfired clay. The edges of the damp clay are roughened with a tool (this is called *scoring*), SLIP is added as the "glue," and the sections are pressed firmly together. The seams of the join can then be smoothed.

MAQUETTE

A three-dimensional preparatory MODEL, usually in CLAY or WAX, which represents on a smaller scale the subject and composition of a sculpture to be executed on a larger scale in a more permanent and expensive material. A maquette is generally more finished and refined in its details, and represents a more advanced stage of compositional development, than a SKETCH. A maquette may serve as, and be synonymous with, a presentation model if it is used to secure approval before work on the final sculpture is undertaken.

MARBLE

A stone composed primarily of calcite (calcium carbonate/ $CaCO_3$) and/or dolomite (magnesium-calcium carbonate/ $CaMg(CO_3)_2$). Marble is formed from the metamorphosis of LIMESTONE in response to the geological forces of heat and pressure. Marble is typically medium- to coarse-GRAINED and, because of the presence of other minerals such as silicates and iron oxides, varies greatly in color and pattern. The term is often used commercially to describe any decorative stone that will take a high polish, including, for example, Purbeck marble (a hard limestone) and serpentine (a magnesium silicate). Colored marble has been used extensively in architecture but only rarely

MAQUETTE
Alfred Stevens (British, 1817–1875). *Maquette for the Duke of Wellington Monument for St. Paul's Cathedral*, 1857. Plaster with enrichments in wax, H: 297 cm (9 ft. 9 in.). V&A, 44–1878.

for sculpture. So-called statuary marble—such as that from Carrara, Italy—is a finer-grained, nearly pure white marble which, when thinly carved, exhibits a startling translucency. The popularity of white marble for European figural sculpture stems from Renaissance interest in archaeological finds of ancient Greek and Roman sculpture executed in this stone. The use of white marble, therefore, evoked associations with the artistic achievements of the ancient world.

CARVING and DRILLING are the primary methods for working marble. Carving a marble block begins with a *point chisel* (also called a *punch*), followed by *claw chisels* (also called *tooth chisels*), then a variety of flat and sometimes *round-headed chisels* (also called *roundels*). The tools can be held at different angles to vary the type of surface achieved. Drilling is used in the POINTING technique to establish the depth to which various locations on a copy should be carved and is also used as a decorative technique to create dark shadows in recesses. Additional shaping and smoothing of the surface is achieved with files, rasps, and scrapers, followed by polishing with abrasives of progressively finer grit. Surface textures of objects represented in marble can be approximated by varying the degree of polish. For instance, a sculptor may give a smooth, glossy polish to a marble figure's torso and limbs but leave the hair rough and unpolished, with tool marks still visible.

Marble is susceptible to damage from natural weathering and airborne pollutants, to breakage due to its inherent brittleness, and to surface abrasion and staining due to handling. In the past, restorers have caused damage: acid washes can cause the loss of surface details, rust from added internal iron supports can cause discoloration and other physical damage, and the migration of soluble salts from cement used for mounting or repair can cause surface erosion.

MEDAL

Medal of Emperor Rudolf II, Bohemian, beginning of the 17th century. Gold, H: 4.15 cm (1⅗ in.); W: 3.32 cm (1³⁄₁₀ in.). JPGM, 92.NJ.87.

The front (obverse) of the MEDAL represents Rudolf II (1552–1612); the back (reverse) includes the emperor's personal emblem and an inscription.

Obverse Reverse

MEDAL

In art historical usage, the term *medal* is used for any small circular flat work that exhibits relief decoration on one or, usually, both sides. Medals can be executed in bronze, silver, lead, or gold. *Medallions* are round or oval reliefs distinguished from medals by their larger size, although the terms are often used interchangeably. Medallions can be executed in any material, including wood, marble, terra-cotta, and bronze, and are often incorporated into larger works of sculpture, such as TOMB monuments. PORTRAIT images typically decorate the front, or obverse, of a medal or medallion, whereas the back, or reverse, usually displays an emblem, symbolic motif, narrative scene, and/or INSCRIPTION that refers specifically to the life or personality of the sitter portrayed on the front. Medals are often similar to coins in size, material, and type of decoration but were not intended for use as currency.

MEDALLION

See MEDAL.

MEDALLION

Joseph Chinard (French, 1756–1813). *Family of General Duhesme*, c. 1808. Terra-cotta, H: 56 cm (22 1/16 in.); L: 70 cm (27 9/16 in.); D: 35 cm (13 3/4 in.). JPGM, 85.SC.82.

In this family group, Madame Duhesme and her young son contemplate her husband's portrait MEDALLION.

MODEL

Albert Ernest Carrier-
Belleuse (French, 1824–
1887). *Model for a Monument
to Alexandre Dumas père*,
c. 1883. Terra-cotta,
H: 79.5 cm (31¾ in.).
JPGM, 94.SC.19.

This MODEL is a preliminary
study for a monument
depicting the famous
novelist, commissioned
by his city of birth.

MODEL

A preliminary version of a projected sculpture, usually executed
in an inexpensive material. Models are typically created through
an additive process of building up and manipulating a sculptural
material, such as CLAY or WAX (see MODELING). However, carved
wood models, created by cutting away material, were used in
northern European countries such as Germany. A model is a
preparatory work, made to facilitate the design and/or execution

of the final sculpture. In English, the term generally applies to all such objects, but other European languages have a more specific vocabulary to designate the model's particular function and its consequent degree of finish and type of surface treatment. Thus the English term *model* encompasses the Italian *bozzetto* and MODELLO and the French *esquisse* and MAQUETTE. Models serve a variety of purposes within the sculptor's studio. In the same way that painters use drawings, sculptors use models for the rapid notation of their ideas in three dimensions (see SKETCH). Models serve as reference tools for the translation of a composition to a larger scale or more permanent material. For example, artists may use plaster POINTING models to reproduce a composition in stone. Wax models are employed in the process of casting metal sculptures (see LOST WAX CASTING). Presentation models, in which all the details of a projected sculpture have been fully worked out, can be shown to a patron to gain approval for the final work or to a prospective client in the hopes of securing a commission (see MAQUETTE). In such instances the model may be painted or GILDED to approximate the material of the projected sculpture.

MODELING

A method of manipulating a sculptural medium such as CLAY, PLASTER, or WAX to create a form. Modeling involves the building up and shaping of a pliable material, in contrast to CARVING, which involves cutting away a hard substance such as stone, wood, or ivory. Hands as well as hand tools, generally long, thin pieces of wood, metal, or ivory, with wire-loop or specially shaped ends, are used for modeling. In art the term *modeling* also refers to the

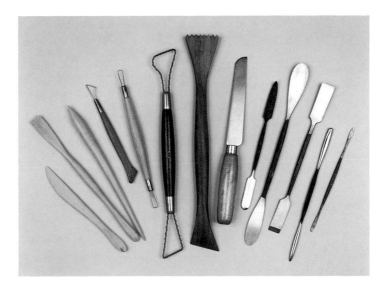

MODELING
Modeling tools include (from left): three double-ended wooden tools, two wire-end tools, a wire-wrapped loop tool, a large serrated wooden tool, an all-purpose knife, three metal spatulas for plaster, a rounded double-ended tool for wax, and a small all-purpose spatula.

MODELING

Louis-François Roubiliac
(French, active in Britain,
1705?–62). *Model for a
Monument to John, 2nd Duke
of Montagu, in Warkton
Church, Northants.*, c. 1750.
Terra-cotta, H: 34.8 cm
(13 ¹¹⁄₁₆ in.); W: 31.8 cm
(12 ½ in.).
V&A, A.6–1947.

Front

The back of this terra-cotta
reveals how the sculptor
built up the volumes of his
composition and then used
tools to further model and
refine the forms on the
front.

Back

treatment of volumes in a sculpted composition and the degree of depth with which the facial features or anatomy of a figure are rendered. Deep modeling maximizes the play of light upon the projections and recesses of a sculpted surface and creates striking contrasts between highlights and shadows. Shallow modeling achieves a more unified but less dramatic surface.

MODELLO
(ITALIAN, "MODEL")

Modello, although often used as a general term, refers specifically to a more finished MODEL (in contrast to *bozzetto,* which designates a SKETCH) and is thus closer in meaning to the term MAQUETTE.

MOLD

The negative impression of a form into which a sculpting material is poured or pressed. Types of molds include: *intaglio molds,* which are carved into stone or ceramic that is resistant to heat; *piece molds,* which can be taken apart without damage to the model, the cast sculpture, or themselves; *waste molds,* which must be broken away to reveal the cast sculpture and therefore can produce only a single casting; *sand molds,* used in SAND CASTING, which are relatively easy to make but must be remade after each use; *flexible molds,* made of gelatin (and today of various elastic polymers such as silicone), which can be used in place of piece or waste molds but may deteriorate; and, finally, *mother molds,* which hold all the sections of a piece mold in proper alignment.

Molds allow for the production of one or many copies of an original model or sculpture. Essentially all major European metal sculpture from the fifteenth through the nineteenth century was cast (or, in the nineteenth century, electrotyped) into molds. CLAY, WAX, PLASTER, STUCCO, BRONZE, BRASS, LEAD, ZINC, silver, and gold can all be cast into molds. *Mold seams* are raised lines, caused by the fine space that exists between the mold sections, which remain on the surface of a piece-molded object. Mold seams are generally removed to hide signs of the sculpture having been mold-made (see FETTLING).

MONUMENTAL

In its most literal sense, the term *monumental* refers to a monument or sculpture of large or over-life-size proportions. However, the term also connotes grandeur, presence, and forcefulness of design and is therefore applied even to smaller-scale sculpture embodying those qualities. See also COLOSSUS.

MORCEAU DE RÉCEPTION

(FRENCH, "RECEPTION PIECE")

A three-dimensional work submitted by a sculptor as a prerequisite for membership in the Royal Academy of Painting and Sculpture in Paris, which was founded in 1648. In order to become a member of the academy, a sculptor presented a plaster or terra-cotta MODEL for approbation. If the academy approved the model, the artist then executed it in marble, usually within a year. When presented with the completed marble, the academy held a formal vote to grant or deny the sculptor full membership. The marble *morceau de réception*, whose subject had been chosen by the academy, became the academy's property upon the admission of each new member.

MULTIPLE VIEWS

Giovanni Bologna, called Giambologna (Flemish, active in Florence, 1529–1608). *Samson and the Philistine*, c. 1567–70. Marble, H: 209.9 cm (6 ft. 10⅝ in.). V&A, A.7–1954.

MULTIPLE VIEWS A term applied to sculpture that is intended to be seen from various points of view, all of which are pleasing and/or essential for understanding the work. The orientation of a sculpture toward more than one viewpoint—compelling the beholder to walk around or turn the object in order to fully appreciate its beauty or comprehend its subject—dominated European Mannerist sculpture and is most often associated with the work of such sixteenth-century artists as Benvenuto Cellini and Giambologna. For these sculptors and their contemporaries, designing a composition that would be successful from many viewpoints was an artistic challenge, the accomplishment of which demonstrated their virtuosity and talent. Compare FRONTAL and PRIMARY VIEW.

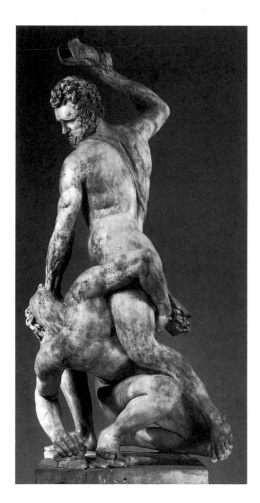 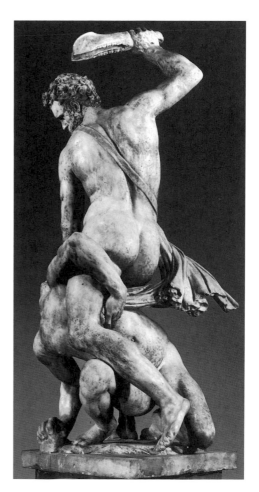

These four views demonstrate that this sculpture was intended to be seen from many angles.

NEGATIVE SPACE

The open or empty space that is defined or framed by sculpted elements within a composition. Because the negative space creates dramatic contrasts, conforms to a geometric shape, or suggests a recognizable form, it often becomes as important to the composition as the tangible sculpted portions.

NICHE

A concave or rectangular architectural recess, often intended for the display of sculpture. The physical relationship of a statue to its architectural niche—whether it appears static and contained within it, whether it seems constrained by it, or whether it appears to burst forward from it—varies greatly with the sculptor and period.

NON FINITO

(ITALIAN, "NOT FINISHED")

A term used to describe a sculpture that is considered unfinished because tool marks are still visible and/or it lacks its final carving, polishing, and refinement of details or a sculpture that is deliberately made to look unfinished. The term is frequently applied to

NON FINITO

Auguste Rodin (French, 1840–1917). *Cupid and Psyche*, c. 1908. Marble, H: 66 cm (26 in.). V&A, A.49–1914.

The unfinished appearance of Rodin's work, most evident here in the rough form and tool marks of the base, was intentional.

Michelangelo's sculptures, many of which were unintentionally left in an incomplete state. These incomplete works later inspired nineteenth-century artists such as Auguste Rodin, who purposefully adopted their rough, unfinished look as an aesthetic ideal.

PASTICHE

A sculpture that copies, imitates, or incorporates elements from various works of art by the same artist or different artists, or from various stylistic periods, and recombines them to create a new work. In the sixteenth through the early nineteenth centuries, the restoration of ancient statues typically resulted in pastiches which combined fragments of ancient sculptures that were originally part of different works or which completed fragments of an ancient sculpture with modern additions. For example, the head of one ancient statue of a goddess might be placed on the body of another, and missing elements, like arms or hands, might be supplied by the restorer. A pastiche is not necessarily intended to deceive, although such recombinations have been used to create forgeries.

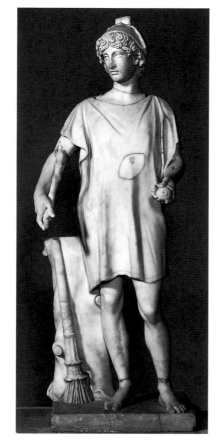

PASTICHE

Paris, Italian, before 1750.
Marble, H: 133cm (52⅜ in.).
JPGM, 87.SA.109.

This statue, prized in the 18th century as an ancient Roman sculpture, is now recognized to be a PASTICHE of ancient and, mostly, modern parts.

A term most commonly used to describe a naturally or artificially induced surface alteration on metal but which also includes coatings applied to metal such as drying oils and paint. A variety of finishes, giving a range of appearances, were used to patinate fifteenth- through nineteenth-century European bronzes. In order to retain the bright, lustrous appearance of a polished or brushed bronze surface, a protective coating of drying oils could be applied, sometimes with resins or pigments added. To achieve a variety of rich golden, to brown, to black surfaces, chemical patinas—mixtures applied to the metal which cause chemical changes—were used. A chemically patinated surface could then be coated with a drying oil and resin lacquer for additional gloss

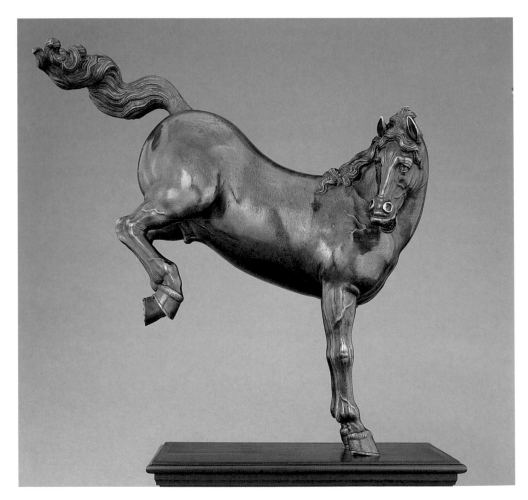

PATINA

Kaspar Gras (German, 1590–1674). *Kicking Horse*, c. 1630. Bronze, H: 34 cm (13½ in.). JPGM, 85.SB.72.

The translucent golden red PATINA of this bronze was achieved by applying a translucent drying oil or resin-based coating to the polished and brushed surface.

or coloring. A more opaque, paintlike coating was also frequently used, possibly to hide casting blemishes. Protective tinted wax coatings of more recent vintage are found on many Renaissance bronzes; as these coatings alter the appearance of the surface, they may be considered part of the patina. Because many early bronzes have been repatinated, the original appearance of the surface has been lost. *Patina* is also used to refer to the natural changes that occur to the surface of nonmetals, for example, the yellowing of ivory with age.

PEDESTAL

See SUPPORT.

PENDANT

A work that is conceived, executed, and intended for display as one of a pair. Similarity in size and subject or symmetry of pose and composition are common devices for associating or visually unifying a pendant with its mate.

PENDANT

Dog and *Bear*, Italian, c. 1580. Bronze, H (of dog): 30.5 cm (12 in.); H (of bear): 29.5 cm (11⅝ in.). JPGM, 86.SB.5.1–2.

Similarities in the size, subject, and treatment of these bronzes and the fact that their poses mirror each other indicate that they were made as PENDANTS.

PLAQUETTE

A small single-sided relief, usually executed in BRONZE, silver, LEAD, or gold, which can take any shape and therefore differs from a MEDAL. The subject matter represented in plaquettes, ranging from religious devotional images to popular mythological themes, is more general than in PORTRAIT medals. In the Renaissance, plaquettes were often incorporated into functional objects such as boxes, oil lamps, and candlestick bases; they could also be hung from a wall or sewn onto clothing.

PLASTER

See GYPSUM PLASTER and LIMEPLASTER.

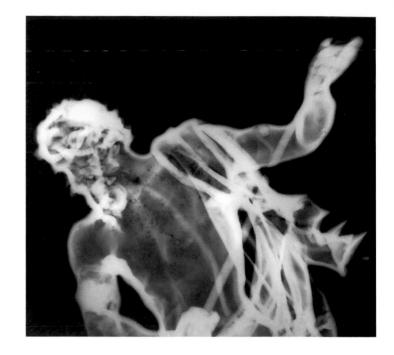

PLUG

After Gian Lorenzo Bernini (Italian, 1598–1680). *Neptune and Dolphin* (side view), c. 1620–80. Bronze, H: 56 cm (22 in.). JPGM, 94.SB.45.

A radiograph (X-ray) of the raised arm of this figure reveals a threaded PLUG in the bicep with a displaced CORE PIN resting adjacent to it.

PLUG

Pieces of metal used to fill the holes left when CORE PINS are removed and to repair small casting flaws (see LOST WAX CASTING). Plugs are generally round, made of an ALLOY very similar to the alloy of the sculpture itself or from SPRUES cut from the sculpture after casting, and are often threaded. The location of core pin hole plugs on figural works can be characteristic of a specific FOUNDRY or workshop. See CORE PINS and CHASING.

POINTING

A mechanical process used for the reproduction of sculpture. The name derives from points marked on a MODEL, which are used to transfer measurements to a marble block as it is being carved. Different types of pointing systems were developed for creating same-size, reduced, or enlarged reproductions. In the eighteenth century and earlier, a large wooden frame was placed first over the model and then over the marble block to provide fixed reference points for measuring horizontal and vertical distances.

The most common nineteenth-century pointing machine consisted of a smaller wooden frame with movable arms. A plaster pointing model was prepared by marking numerous point locations on its surface in pencil. A number of raised reference spots were also set into the plaster to serve as the main locations on which the pointing machine would rest while measurements were being taken. The frame was secured to the model's reference

POINTING
In this late 19th-century illustration, the artist is shown with a POINTING machine resting on the raised reference points of the sculpture being copied. ("The Pointer at Work" from *Technique of Sculpture* by William Ordway Partridge [Boston, 1895], fig. 19.)

spots and the movable arm or arms positioned so that the exact location of one or more pointing marks was registered. The frame was then secured to the corresponding reference points on the marble, and the movable arm used to indicate the depth to which each location on the marble should be drilled. Once the holes were drilled, the marble remaining between the holes was carved away. In cases where the artist chose not to carve to the full depth of the drilled hole, remnants of the pointing marks can often be seen as concave areas recessed below the finished marble surface.

Pointing allowed the rapid roughing-out of marble sculptures in any desired size. It allowed the artist to freely develop his forms in a more pliable material such as CLAY or WAX, while the casting of the model in plaster and some, or all, of the marble carving could be carried out by skilled technicians and professional stonecutters.

POLYCHROMY

The decoration of a surface in many colors, often, but not necessarily, including metallic treatments such as GILDING. In sculpture the term generally refers to carved and painted wooden reliefs or sculpture in-the-round although terra-cotta, ivory, limestone, marble, alabaster, plaster, stucco, and even bronze were sometimes colored. The techniques for painting polychrome WOOD sculpture are similar to the materials and techniques used for panel paintings. Carved wooden polychrome sculpture was coated with animal glue; then the joins, any knots, and occasionally the entire surface were covered with fabric to help reduce cracking of the decorative layers (see JOIN). Numerous layers of GESSO were then applied and smoothed or carved in preparation for the addition of color. Oil-based paints could be used for flesh areas to give a rich surface which varied from high to low gloss. A matte surface could be achieved with egg tempera or glue-based

paints. The artist had a broad choice of techniques for the depiction of textiles: the gesso could be scored or carved to create patterns or designs beneath the applied surface decoration; oil and tempera could be combined to achieve different levels of gloss; or gilding or silver leaf colored with translucent GLAZES could be applied (see SGRAFFITO).

Surface texture was achieved by using PUNCHES in the gilded areas or by applying raised reliefs of gesso or WAX. Although raised patterns could be created by stamping a design into the damp gesso directly on the sculpture, most gesso and wax appliqués were formed in molds and were fully painted and/or gilded before being applied to the sculpture. In order to enhance a work's realism, actual gemstones or glass could be used to represent jewels or drops of blood or tears. Glass eyes, removable clothes, and wigs were also used. Beginning in the late fifteenth century in Germany, a style sometimes referred to as *monochromy* developed, in which sculptures carved of limewood received only a small amount of translucent surface coloring. This aesthetic altered the artist's approach, placing greater emphasis on CARVED textures. However, monochromy remained a relatively minor art, and most wooden sculpture was once painted, even if it has since been stripped of its color because of changing tastes.

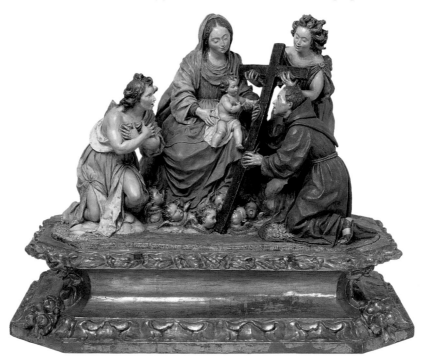

POLYCHROMY

Luisa Roldán, called La Roldana (Spanish, 1652–1706). *Virgin and Child with Saint Diego of Alcalá*, c. 1690–95. Polychrome and gilt wood, H (with base): 51 cm (20 in.); W (with base): 66 cm (26 in.); D (with base): 41.5 cm (16⅜ in.). V&A, 250–1864.

Any representational likeness of an individual. The most common form of portraiture depicts a man, woman, or child of known appearance, who is referred to as a sitter to indicate that he or she posed, or sat, for the artist. In the absence of a live sitter, a painted or drawn image could serve as the basis for a sculpted portrait. Representations of historical figures whose appearances can only be surmised are referred to as imaginary portraits. A portrait may be sculpted IN-THE-ROUND, using either a full-length or BUST format, or in RELIEF. Portraits vary in the degree of accuracy with which the subject or sitter is depicted. In contrast to an idealized portrait, which modifies a person's particular features to accord with a norm or an accepted standard of beauty, a highly naturalistic portrait carefully records the imperfections in an individual's features. Most portraits fall somewhere between these two extremes—the degree of realism or idealization being determined by various factors, including the patron, the artist, the period, or the purpose of the portrait commission. Sculpted portraits serve a variety of functions. Primarily, they record a person's physical appearance for posterity. The practice of producing portrait sculpture from MOLDS taken from the face of a living person (a life mask) or from that of a deceased person (see DEATH MASK) is an obvious manifestation of this aspect of portraiture. Portraits also fulfill the propagandistic aims of rulers and aristocrats by promoting and perpetuating their images through portrait monuments, portrait MEDALS, or TOMB portraits. Allegorical portraits associate the sitter with a classical god or abstract concept, such as Jupiter or Justice, to elucidate or shape the sitter's public image. Portraits may serve as objects of veneration and religious devotion, as in portraits of saints.

Sculpted portraits offer several advantages, both real and perceived, over painted portraits. Three-dimensional sculpture convincingly replicates the volumes of the human body and has a tangible physical presence. BRONZE and MARBLE possess the stability and permanence necessary for outdoor public monuments, and sculptural materials themselves convey specific messages central to the sculpted portrait. For example, the costliness of marble and bronze testifies to the wealth of the sitter. The choice of these materials also evokes Greek and Roman precedents in which marble or bronze were used to portray famous personalities and emperors, and can serve to demonstrate the sitter's erudition in antiquarian matters.

PRESS MOLDING

Also called squeeze molding. A technique in which CLAY is pressed (or squeezed) into an open MOLD or piece mold. When a piece mold is used, clay is pressed by hand onto the interior surface of the individual mold sections. The mold sections are then brought together, the clay edges are joined (see LUTING), and the seams, where accessible, are smoothed. The assemblage is held together in a mother mold until the clay begins to dry and shrink away from the mold, at which time the mold sections are removed. Press molding ensures a uniform thickness of clay, thereby avoiding cracking during drying and firing. The advantage of press molding over SLIP CASTING is that clay mixed with *grog* (ground up fired clay) can be used, allowing for thicker walls and less shrinkage. Press molded terra-cottas can be distinguished from slip cast terra-cottas by their extra weight and by the presence of smoothed join lines in the interior.

PRIMARY VIEW

The angle from which a sculpture yields its most pleasing, comprehensive, and informative view. The primary view of a sculpture may be from an oblique angle or from the side rather than from the front. Often the orientation of the BASE or SOCLE can help the beholder ascertain the optimum, or primary, viewing angle for that sculpture. The other angles from which the sculpture may be examined are referred to as *secondary views*. Secondary views may also be pleasing and important to the understanding of a work, but to a lesser degree. On the other hand, some compositions appear fragmentary, disjunctive, or implausible when seen from any angle but the primary view. An artist must consider the setting and function of his or her sculpture when designing a composition for one or more views. For instance, a NICHE statue is seen primarily from one angle, but a garden statue may be viewed from many different angles. See also MULTIPLE VIEWS.

PUNCH

A tool used to impress a decorative design or pattern into a metal, wood, or gilded GESSO surface. A punch is generally a long metal rod with a tapering end into which patterns are cut. The other end of the punch is struck with a mallet or hammer at a 90 degree angle to the surface. Punches are used in CHASING a cast bronze surface to sharpen details. Punched designs can augment GILDED and SGRAFFITO surfaces in POLYCHROMED sculpture. The term is also an alternate name for the *point chisel* used in MARBLE carving.

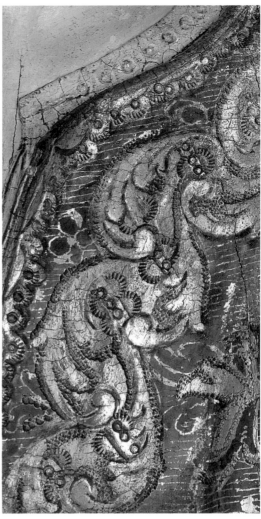

PUNCH

Francisco Salzillo (Spanish, 1707–1783). *Saint Joseph*, c. 1760–70. Polychrome and gilt wood,
H: 145 cm (4 ft. 8 in.). V&A, A.2–1956.

As can be seen in this detail of the figure's robe, a variety of PUNCHES were used in combination with SGRAFFITO.

REDUCTION

A reproduction on a smaller scale of a work of sculpture already in existence. Reductions as well as enlargements were made by using calipers or proportional compasses to transfer measurements taken from the original sculpture (and then either decreased or increased in accordance with mathematical proportions) to the reproduction. More sophisticated mechanical instruments, such as the Colas machine, used for reductions, and pantographs and pointing machines, for reductions as well as enlargements, became popular in the nineteenth century. See POINTING.

REDUCTION
"Collas Sculpture Reducing Machine" from *La France Industrielle* by Paul Poiré (Paris, 1880), fig. 394. (Photo courtesy of the Bard Graduate Center for Studies in the Decorative Arts, N.Y.)

RELICT CAST

(ITALIAN, *RICORDO*, "RECORD" OR "SOUVENIR")

A unique bronze cast made directly from a studio MODEL or SKETCH to preserve it in a more permanent and durable material. Relict casts were made from models never intended by the artist to be independent works of art for display but rather to be kept in the studio as reference tools for future compositions. They were usually executed by another sculptor or workshop some time after the original artist created the model and may record the model in a damaged state, since repairs were rarely made prior to casting. For these reasons, relict casts may be technically inconsistent with, or less visually pleasing than, an artist's other works.

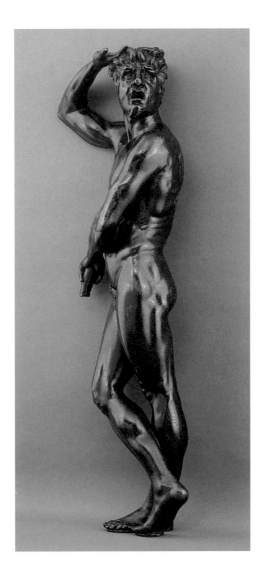

RELICT CAST

Benvenuto Cellini (Italian, 1500–1571). *Satyr*, cast from a model of c. 1542. Bronze, H: 57 cm (22 7/16 in.). JPGM, 85.SB.69.

This bronze was most likely cast from a model abandoned in his workshop when Cellini left France to return to his native Florence.

RELIEF Sculpture in which the elements of the composition project from the surface of a more or less flat background, known as the relief plane. Relief sculpture is classified according to the degree of projection from the relief plane. High relief, called *alto rilievo* in Italian, exhibits the greatest degree of projection, in which more than half the mass of each compositional element extends out into space. In low relief (Italian, *basso rilievo*; French, *bas relief*) less than half the mass of each figure or decorative motif projects from the relief plane. Middle relief (Italian, *mezzo rilievo*) falls between high and low relief in its degree of projection. High, low, and middle relief are often combined in a single work in order to

RELIEF

Donatello (Italian, c. 1386–1466). *The Ascension with Christ Giving the Keys to Saint Peter*, c. 1428–30. Marble, H: 40.6 cm (16 in.); W: 114.3 cm (45 in.). V&A, 7629–1861.

An example of *rilievo schiacciato*, or very low, "crushed," RELIEF.

RELIEF

Christoph Daniel Schenk (German, 1633–1691). *The Conversion of Saint Paul*, 1685. Limewood, H: 36.6 cm (14 in.); W: 26.2 cm (10 in.). JPGM, 96.SD.4.1.

This work combines low and high RELIEF; some elements of the composition project so far out from the background that they are fully detached.

vary the composition, play with spatial illusion, and/or hierarchically order the images represented. In very shallow relief, better known as *rilievo schiacciato*, or *stiacciato*, from the Italian for "squashed" or "flattened," the elements of the scene or composition barely project beyond the surface, and an illusion of spatial recession is achieved by undulating the surface within a very limited range of depth. The desired aesthetic in *rilievo schiacciato* is closely related to the conventions of spatial representation in paintings. Hollow relief (Italian, *cavo rilievo*) is a type of sculpture in which the forms of the composition project below the surface toward the unseen back of the relief panel, hence reversing the usual relationship between sculpted elements and their background. In hollow relief the compositional elements are concave rather than convex in relation to the surface. See also WOOD.

RELIQUARY

A box or sculpted container made as a repository for preserving, displaying, and glorifying sacred relics (objects associated with revered individuals or anatomical fragments taken from their bodies), which were considered holy and believed to possess mystical or talismanic powers. The contents of a reliquary sometimes determined its form. For instance, a reliquary in the shape of an arm or hand might house a saint's finger, and a reliquary head might contain locks of hair, teeth, or skull fragments.

REPLICA

See EDITION.

SAND CASTING

A technique for casting metals, which was first used for simple sculpture and utilitarian objects in the Renaissance, grew in popularity in the early eighteenth century, and became the primary method for casting iron and bronze in the nineteenth century. In sand casting, a piece MOLD is made from a plaster, bronze, wood, terra-cotta, or wax MODEL using a sand fine enough to record details, yet permeable enough to allow gases to escape. The sections of the piece mold are held together and supported in two iron boxes (called *flasks*) packed with coarser sand.

A simple sand CORE can be built up by hand or the piece mold can be completely filled with sand, which is then carved to form the final core shape. An alternative method for forming sand casting cores, which became popular in the nineteenth century, is to fill the piece mold with plaster, which is then carved down to the shape of the final core. A mold taken from the plaster core is then used to cast numerous sand cores. The finished core is held in place with metal CORE PINS or with wires that protrude from the ARMATURE into the surrounding piece mold sections. Channels are cut into the piece mold: *gates* to allow for the

free flow of molten metal and *vents* to aid the release of air and gases. After the mold sections and core are baked to evaporate water and harden the sand, the flasks are secured tightly together, set on end, and the molten metal is poured into the gates. Once the metal has cooled, the flasks are opened, the sand is knocked away, the core and armature are removed as much as possible, and the surface is CHASED (including the removal of raised mold lines) and PATINATED.

As the technique developed, casting of more elaborate sculptures became possible, although highly complex compositions had to be cast in separate sections and then joined. Sand cast sculpture differs from sculpture made by the LOST WAX process in the "stepped" quality of its interior (a result of the core's being carved rather than modeled) and its overall rough and pebbly interior texture. Because of the efficiency with which the sand absorbs gases released during casting, sand casts generally exhibit less porosity than lost wax casts (see LOST WAX CASTING).

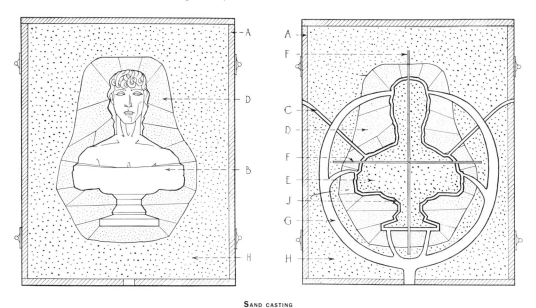

SAND CASTING
This drawing illustrates the preparation of sand molds for casting. On the left, the model rests in one half of the mold. On the right, the model is removed, and the mold is further prepared for casting.
(A) iron flask, (B) model around which the mold is made, (C) vents, (D) sand piece mold sections, (E) sand core, (F) iron armature, (G) gates, (H) coarser sand supporting the piece mold sections.
("The Casting of a Bust in Metal" from *Crafts in Architecture* by Gerald K. Geerlings
[New York, 1929], figs. 17 and 18.)

SANDSTONE

Style of Rovezzano (Italian, c. 1474–1554). *Frieze*, first quarter of the 16th century. Pietra serena,
H: 52.4 cm (20⅝ in.); L: 175.3 cm (5 ft. 9 in.). V&A, 8380–1863.

A very hard, fine-grained dark gray sandstone, *pietra serena* was used in Florence for both
architecture and sculpture.

SANDSTONE

A sedimentary stone composed of quartz (a crystalline form of silica, SiO_2) bound together by one of a number of materials including silica (in a less crystallized form), calcite, dolomite, or various iron oxides. The porosity, durability, and working characteristics of the different types of sandstone vary greatly and are determined by the size of the quartz grains, the type of binding material (also called the *cementing* material), and the type and amount of other inclusions. Sandstone can be carved with precision but cannot be polished. The carving tools used for sandstone are similar to those for MARBLE—chisels, rasps, and DRILLS—although the greater softness of some varieties allows the use of gouges, scrapers, and wooden mallets. Sandstones are susceptible to damage from crystallization of soluble salts picked up from the soil, from improper cleaning solutions, or from adjacent concrete or cement. In a polluted outdoor environment, many sandstones are comparatively resistant to attack; however, those bound by calcite will deteriorate rapidly.

SARCOPHAGUS

A long, covered coffin, usually made of stone or marble but sometimes executed in terra-cotta. Originally intended in ancient Greek and Roman times to contain the decomposing corpse, the sarcophagus became a symbolic form evoking funereal associations in European TOMB sculpture. The lid and sides of sarcophagi were often used as fields for INSCRIPTIONS or RELIEF decoration.

SECONDARY VIEWS

See PRIMARY VIEW.

SGRAFFITO

Luisa Roldán, called
La Roldana (Spanish,
1652–1706). *Saint Gines*,
169(2?). Polychrome and
gilt wood (pine and cedar)
with glass eyes, H: 176 cm
(69¼ in.).
JPGM, 85.SD.161.

The rich, seemingly woven
texture of the brocade pattern
in the saint's robe was achieved
using SGRAFFITO.

The sequence of steps in the
SGRAFFITO technique is seen
below. From left to right:
the wood is sealed with animal
glue; a white GESSO ground is
applied; a colored bole layer
is applied and smoothed; gold
leaf is applied; the gold is
BURNISHED; then the entire
GILDED surface is painted,
the paint is scratched off in
patterns, and PUNCHES are
used to create highlights.
(Didactic panel by
N. Ravenel.)

SGRAFFITO

(SPANISH, *ESTOFADO*)

Derived from the Italian words *sgraffiato* (scratched) and *graffito* (a drawing), *sgraffito* refers to the technique of scratching through one paint layer to reveal another layer of contrasting color or material. In POLYCHROME sculpture, the technique involves water GILDING and burnishing the entire surface, which is then completely covered in egg tempera that is carefully scratched through with a small blunt-tipped tool so that the gilding is revealed in patterns. The contrasts in color between the gold and the paint are accentuated by the contrasting texture of the matte tempera and the brilliant burnished gold. *Sgraffito* was used extensively to depict the rich texture of fabric, such as liturgical robes embroidered with metallic threads. Although stencils were sometimes used for transferring patterns, *sgrafitto* designs were often drawn freehand.

SIGNATURE

See INSCRIPTION.

SKETCH OR SKETCH MODEL

A small, preliminary version of a sculpture executed in CLAY, WAX, or other inexpensive, pliable material, which the artist uses to work out and record the forms, proportions, and composition of a projected work in a more permanent medium. Also known by the terms *esquisse* (French) or *schizzo* or *bozzetto* (Italian). Because it represents an early stage in the creative process, a

SKETCH
Giovanni Bologna, called Giambologna (Flemish, active in Florence, 1529–1608). *Rivergod*, c. 1579–80. Terra-cotta, H: 33 cm (13 in.); L: 39.7 cm (15 3/8 in.). V&A, 250–1876.

sketch may differ substantially from the final sculpture. A loose, energetic handling of the material—which sometimes preserves the sculptor's fingerprints and tool marks—is characteristic of the sketch. Beginning in the sixteenth century three-dimensional sketches were collected and valued as independent works of art, at first because of their association with great masters and later because of a changing aesthetic that prized the sketch's immediacy and its direct recording of the sculptor's initial thoughts. See MODEL and MAQUETTE.

SLIP

A very fluid, smooth mixture of CLAY and water having the consistency of cream. Slip is used as a glue for joining clay sections together (see LUTING). To create decorative effects, slip made of the same clay as the body of the sculpture, or of a different colored clay, can be applied to part or all of a terra-cotta surface before firing. When applied over the entire surface slip tones or unifies the color of a clay sculpture. When applied to selected areas or details, it creates subtle, decorative polychrome effects. Slip can also be used to cast clay forms (see SLIP CASTING).

SLIP CASTING

A method of casting clay sculpture by pouring SLIP into a plaster MOLD. The fine, even consistency of slip allows for good reproduction of details. In preparation for casting, small amounts of a chemical such as sodium carbonate or sodium silicate (known as *deflocculants*) are added to the slip to produce a mixture with a low water content that nevertheless remains free-flowing. As the remaining water is pulled out of the slip by the porous plaster, an even deposit forms on the interior of the mold. When the desired thickness is achieved, the excess slip is poured out. The drying clay begins to shrink, pulling away from the mold and facilitating removal. Slip casting was popular in the nineteenth century for reproducing complex TERRA-COTTA sculptures in parts, which were then joined (see LUTING) before firing.

SLUSH CASTING

A method of casting in which PLASTER, molten WAX, or molten metal is poured into a prepared MOLD. The mold is rotated to coat the interior as evenly as possible with the fluid casting material. Once the desired amount of material has built up on the walls of the mold, the excess is poured out. ZINC, tin, and LEAD were commonly slush cast in iron or brass molds. The term *slush molding* refers to the use of this technique to create the wax model used in the indirect method of LOST WAX CASTING.

SLUSH CASTING (also called *slush molding*) of a wax leg in a three-piece mold. (Photos courtesy F. Bewer.)

(a) The mold sections are brought together.

(b) The molten wax is poured into the mold.

(c) Excess wax is poured out, and the process is repeated until the wax is of the desired thickness.

(d) The hollow leg is removed from the mold.

A radiograph (X-ray) of a sculpture created using slush casting or slush molding will reveal a smooth interior and walls that are thicker where more of the casting material built up during rotation of the mold and thinner where it covers interior projections.

SOCLE

See SUPPORT.

SPRUES

The channels (also referred to as *gates*) that allow molten metal to flow into the mold cavity during LOST WAX CASTING. The term is often used to refer to the entire channeling system, including the *vents* or *risers* that allow air and gases to escape as the metal enters the mold and cools. Sprues and vents are formed by attaching solid wax rods to the wax model before the outer mold (INVESTMENT) is applied. When the wax is melted out, empty channels remain in the investment. Once metal is poured into them and hardens, the sprues and vents become solid metal protrusions, which must be removed in the CHASING process.

STATUE	A sculpture IN-THE-ROUND which represents an entire figure or animal.
STATUETTE	A sculpture IN-THE-ROUND representing an entire figure on a scale that is substantially smaller than life-size (usually less than one-half life-size in height). BRONZE statuettes were popular among collectors in the ancient world and were revived as a sculptural genre in Europe at the end of the fifteenth century.

STRUT

Joseph Nollekens (British, 1737–1823). *Diana*, 1778. Marble, H (without pedestal): 94 cm (37 in.); W: 57 cm (22⅜ in.); D: 57 cm (22⅜ in.). V&A, A.5–1986.

A STRUT connects the two arms of the goddess, who is posed to shoot a bow and arrow. The large tree stump SUPPORT, needed to bear the running figure's weight, is awkwardly placed between her legs.

Strut

A narrow piece of stone connecting two parts or limbs of a stone sculpture which would otherwise be extremely fragile and susceptible to breakage. Struts are often needed to strengthen and support a projecting element of a composition, such as an arm, by reinforcing its attachment to the main block or mass of stone. Struts are also used in wood, ivory, or stone compositions to link together small, delicate individually carved elements, like fingers or tree leaves, to prevent them from snapping off. Since struts frequently were removed once a sculpture was permanently installed and the risk of damage minimized, their presence may suggest that the sculpture was never placed in its intended setting nor given its final touches.

Stucco

A mixture containing GYPSUM PLASTER and/or LIMEPLASTER combined with sand and additives such as marble powder, animal glue, white wine, resins, or milk, which increase its durability and lengthen the time during which it is workable. Stucco is slow setting and hardens at room temperature. It was used most widely for elaborate RELIEF decorations in churches and, beginning in the sixteenth century, secular settings. Its use peaked in the seventeenth and eighteenth centuries, particularly in central and

Stucco

Serpotta (Italian, 1656–1732). *Cherub Head*, c. 1700. Stucco, H: 26.7 cm (10½ in.). V&A, A.62–1951.

This head is typical of sculptural STUCCO work used in architectural settings.

southern Europe, where it was employed for relief as well as free-standing sculpture. Stucco reliefs and statues were either MOLD-made or MODELED, with an interior ARMATURE to add strength to larger compositions. Stucco surfaces were often decorated with POLYCHROMY, GILDING, or BRONZING, or they could be highly polished and waxed to resemble marble.

SUPPORT

In its most general sense, anything that holds up and/or bears the weight of a sculpture from below. A support accomplishes one or all of the following: bearing a sculpture's weight, raising its height to the desired viewing level, and achieving a pleasing visual transition between the sculpture and the ground. *Support* encompasses the more specific terms *socle*, *pedestal*, and *base*.

SUPPORT
Ernst Friedrich August Rietschel (German, 1804–1861). *Bust of Felix Mendelssohn*, 1848. Marble, H: 59.7 cm (23½ in.). JPGM, 86.SA.543.

An example of a portrait bust placed on a SOCLE.

SUPPORT

LEFT: Gaspard Marsy
(French, 1624–1681).
Boreas Abducting Orithyia,
cast c. 1693–1710. Bronze,
H: 105 cm (41⅓ in.).
JPGM, 88.SB.74.

RIGHT: François Girardon
(French, 1628–1715).
Pluto Abducting Proserpine, cast
c. 1693–1710. Bronze,
H: 105 cm (41⅓ in.).
JPGM, 88.SB.73.

PEDESTALS attributed to
André-Charles Boulle
(French, 1642–1732).
Gilt brass and tortoise shell
marquetry in *première partie*
and *contre-partie* with ebony
veneer, H (of each):
121 cm (47⅜ in.).
JPGM, 88.DA.75.1–2.

In the 18th century, this pair
of bronzes was set on their
richly decorated PEDESTALS.

A socle (sometimes referred to by the French word *piédouche*) is a small, three-dimensional support of varying form—round, square, rectangular, polygonal, or composite—usually decorated with moldings at top and bottom, and sometimes waisted in the middle. A socle can be made of the same material as the object it supports or of something different. If it is executed as part of the sculpture (for example, carved from the same piece of stone or cast together in bronze), the socle is said to be integral to the work of art. Socles may be decorated with RELIEF scenes, INSCRIPTIONS, or applied MEDALLIONS or PLAQUETTES. A socle typically serves as a transitional element between a sculpture and the pedestal or piece of furniture on which it is displayed.

A pedestal is a support of larger dimensions; it can be tall and narrow to hold up a STATUETTE or BUST or deep and wide to

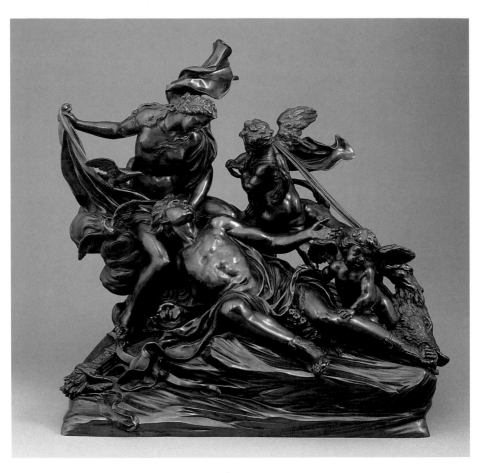

SUPPORT

Massimiliano Soldani-Benzi (Italian, 1656–1740). *Venus and Adonis*, c. 1700. Bronze,
H: 46.4 cm (18 ¼ in.); W: 49 cm (19 ¼ in.). JPGM, 93.SB.4.

The integrally cast, striated BASE of this complex bronze group is meant to evoke a rocky landscape.

bear a large figure or sculptural group. A traditional pedestal
consists of three basic elements: the top section, called a *cornice*
or *surbase*; the middle section, or body of the pedestal, called a
dado or *die*; and the part of the pedestal nearest the ground,
called a *foot*, *plinth*, or *base*. Conventionally, the dado is the most
slender element, with the cornice and plinth projecting outward
to convey an impression of stability at the top and bottom. A
pedestal's dado may display an inscription or relief decoration
elucidating the subject of the sculpture it supports.

Technically, the term *base* connotes the lowest part of a col-
umn or, by extension, pedestal. However, it has become a fairly
generic term in common usage and is often employed inter-

changeably with socle and pedestal. *Base* is also used to describe a support for which the other two terms seem inappropriate. For example, European seventeenth- and eighteenth-century bronzes were typically cast with a short supporting element decorated on its top surface with scenographic details of a landscape, clouds, or water. This support, which served to stabilize the bronze and suggest a natural setting for the sculpted image, is referred to as a base.

The term *support* also describes the element or elements within a stone composition that bear the weight and redistribute the downward thrust of the sculpture. For instance, the tree-stump supports so ubiquitous in marble figural sculpture are necessary to carry the weight of naturalistic stone figures that might otherwise snap or break at their slender ankles.

TERM	See HERM.
TERMINATION	See TRUNCATION.
TERRA-COTTA (ITALIAN, "BAKED CLAY")	Coarse-grained clay that has been fired at low temperatures and left unglazed. European terra-cotta sculptures vary in color from off-white to light brown or reddish orange. The term *terra-cotta* also encompasses polychrome GLAZED works, such as those produced in the fifteenth and sixteenth centuries by the della Robbia workshop in Florence. Terra-cotta has been used for molds, pottery, and architectural elements as well as for sculpture. Terra-cotta sculptures are formed either by MODELING or by casting in MOLDS (see CLAY) and are then fired. Because of clay's low cost and the ease with which it can be modeled, terra-cotta was used to create SKETCHES for works to be executed in other, more expensive materials such as marble and bronze. Unglazed, unpainted terra-cotta was considered primarily a preparatory medium until the eighteenth century, when it began to be appreciated as a sculptural material in its own right.

The size of terra-cotta sculpture is limited by the size of the KILN, but very large compositions can be made in separately fired sections which are then joined. The ideal firing temperature for a terra-cotta sculpture usually varies between 700 and 1000 degrees Centigrade, depending on the clay components and conditions within the kiln. Unglazed terra-cotta is fired only once. If glazes are used, the sculpture must receive at least one additional firing.

Unglazed terra-cotta could be painted and GILDED using the same methods and materials found on contemporary stone and wood sculpture, an aesthetic which was popular in the early

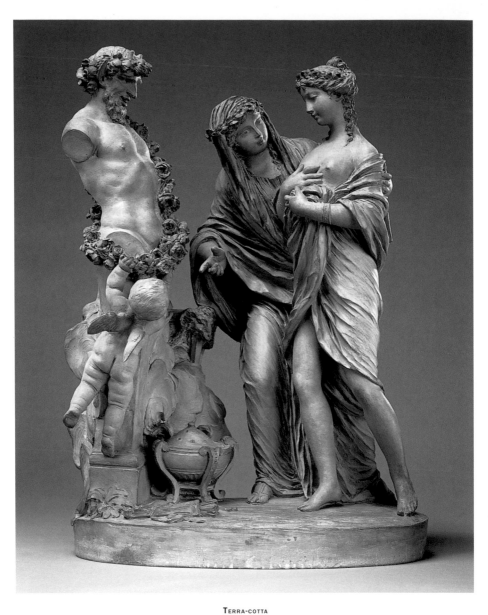

TERRA-COTTA

Claude Michel, called Clodion (French, 1738–1814). *Vestal Presenting a Young Woman at the Altar of Pan*, c. 1770–75. Terra-cotta, H: 45 cm (17¾ in.). JPGM, 85.SC.166.

Renaissance (see POLYCHROMY). In the eighteenth century, a taste developed for more subtle uses of color or, in appreciation of the raw terra-cotta surface, no color at all. Terra-cottas were also painted in imitation of marble or bronze or coated with terra-cotta-colored paints intended to hide blemishes such as cracks, JOINS, mold lines, and variations in surface color. The current taste for unadorned terra-cotta has perhaps driven well-intentioned but misguided modern cleanings in which original eighteenth-century paint has been removed.

TERRA-CRUDA
(ITALIAN, "RAW CLAY")

A term used to distinguish dry, unfired clay from TERRA-COTTA. Also referred to in English as *greenware*. Terra-cruda was used extensively as a MODELING material, but because it is water soluble and very fragile, most unfired clay models are now lost.

TOMB

A commemorative monument, often combining sculpture and architecture, dedicated to a deceased person or persons buried in that location. A similar monument erected in honor of someone whose remains are buried elsewhere is called a *cenotaph*. Although the conception and design of sculpted tombs varies

TOMB
Nicholas Stone (British, 1586–1647). *Tomb of Sir Moyle Finch and His Wife*, c. 1630. Alabaster and marble, H: 172 cm (5 ft. 7¾ in.); L: 469.9 cm (15 ft. 5 in.); W: 464.8 cm (15 ft. 3 in.). V&A, A.186–1969.

considerably depending on the physical context, the period, and the wishes of the patron, one element essential to all sculpted funerary monuments is the identification of the deceased. An INSCRIPTION naming the dead person, often accompanied by a commemorative phrase or dedication called an *epitaph*, is the simplest means of achieving this identification. The inclusion of a SARCOPHAGUS or coffin provides a surface for the inscription and further enhances the funereal aspect of the monument by implying the presence of the corpse. A more visual and immediate identification of the deceased is accomplished by incorporating his or her image in the form of a BUST, PORTRAIT MEDALLION, or *effigy* (a full-length portrayal of the deceased in a supine position, as if dead or asleep).

The use of the sculpted effigy, represented as if laid out on a sarcophagus or funeral bier, became popular in European tomb sculpture from the thirteenth century on. Although in general practice corpses were covered by shrouds or placed in closed coffins, deceased members of the religious and secular elite— for example, popes, cardinals, kings, and nobles—were clothed in official robes and displayed to the public during their funerals and funeral masses. The motif of a sculpted effigy atop a sarcophagus or bier probably reflects this custom. The incorporation into tomb sculpture of a portrait of the deceased as alive and involved in everyday activities (for instance, a statue of a pope bestowing benedictions) first occurred in the late fifteenth century but became much more common in the Baroque period and later. Often the life image was combined with an effigy in the same monument, visually underscoring the contrast between life and death. Other recurring elements of sculpted tombs include allegorical figures and ornamental or figural RELIEFS. The types of figures commonly found on tombs range from simple angels holding COATS OF ARMS or candelabra to life-size personifications of the Virtues, often shown mourning. Sculpted reliefs typically illustrate scenes from the deceased person's life.

Tombs usually take one of three forms: a *floor tomb*, in which an epitaph or relief effigy is installed in the pavement of the floor; a *wall tomb*, in which an architectural framework attached to the wall provides the structure and context for the sculpted elements, or those elements are themselves mounted to the wall; or a *freestanding tomb*, which is independent of the surrounding architecture and can be viewed from all sides. Large freestanding tombs were less common in many European countries since they were unsuitable for the interiors of smaller churches. However, by the middle of the eighteenth century the overcrowding of church burial sites had become a matter of growing public con-

cern, and by the nineteenth century large public cemeteries had been established, leading to an increase in freestanding outdoor funerary monuments.

TOOL MARKS Marks left in a sculpted surface by the tools used to create or finish the sculpture. Tool marks are often valued as a direct record of the artist's efforts. Tool marks can be useful in dating a sculpture, particularly one of wood (power tools were introduced in the nineteenth century and evidence of their use precludes an earlier date). One method of determining the condition of a sculpture is to look for abrasion, etching, or loss of the tool

TOOL MARKS

Francesco Antonio Franzoni (Italian, 1734–1818). *Sketch for a Fireplace Overmantel* (detail), c. 1789. Terra-cotta, H: 53.5 cm (21¹⁄₁₆ in.). JPGM, 95.SC.77.

Loose sketching of the clay with a *stylus* (a sharp pointed tool) imparts a liveliness to the terra-cotta surface.

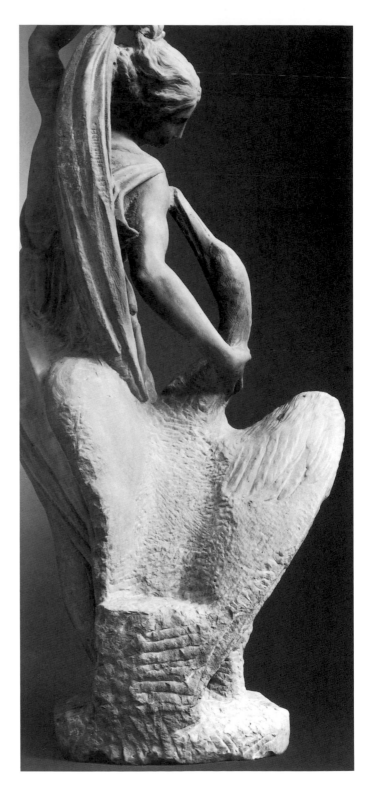

TOOL MARKS

Bartolomeo Ammanati
(Italian, 1511–1592). *Leda
and the Swan* (back view),
c. 1535. Marble, H: 138.4 cm
(4 ft. 6½ in.).
V&A, A.100–1937.

The TOOL MARKS shown here
were left by a point chisel, a
tooth chisel, and a flat chisel.

Tool marks

Joseph Chinard (French,
1756–1813). *Bust of
Madame Récamier* (detail),
c. 1801–02. Terra-cotta,
H: 63.2 cm (24⅞ in.).
JPGM, 88.SC.42.

Tool marks from a toothed
wooden modeling tool are
visible underneath the base
of this bust. They are also
visible on the base of
Chinard's sculpture as it
appears on the final page
of this book.

marks in exposed areas as compared to those found in recessed
or hidden areas. A great disparity between the two generally indi-
cates some loss of the original surface, often due to excessive
cleaning or erosion.

Truncation

The way in which the lower portion and bottom edge of a
sculpted BUST is treated. The artist's approach to this truncation
determines how much of the human body is included in a repre-
sentational bust and how that body is terminated to establish its
bottom boundary. The term is interchangeable with *termination*.
In the fifteenth century, PORTRAIT or allegorical busts often
included the shoulders and upper portion of the arms, ending
in a straight horizontal line above the elbows, a format probably
derived from RELIQUARY busts. This type of truncation encour-
aged the viewer to complete the partially depicted body in his
or her own imagination but did nothing to mitigate the abrupt
cutting-off of the figure. By the end of the fifteenth century, with
the increasing awareness and admiration of ancient busts, termi-
nations in which the subject's nude or partially draped chest
ended in a continuous curved line became increasingly popular
in humanist and courtly circles because of their conscious emu-
lation of antiquity. These classicizing busts usually included
the shoulders and chest, or only the chest, and were placed on
SOCLES. Mannerist artists of the late sixteenth century sometimes

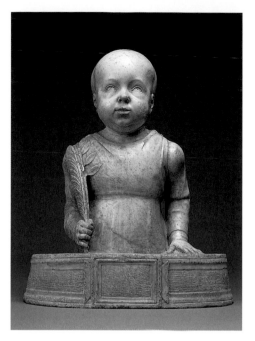

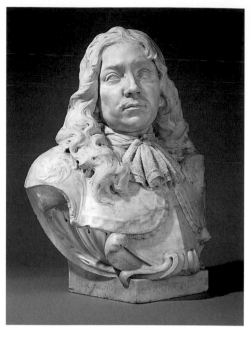

TRUNCATION
Francesco Laurana (Italian,
c. 1420–1502). *Saint Cyricus*,
c. 1474–76. Marble,
H: 49.5 cm (19½ in.).
JPGM, 96.SA.6.

Rombout Verhulst (Dutch,
1634–1698). *Bust of Jacob
van Reygersberg*, 1671.
Marble, H: 63 cm (24¾ in.).
JPGM, 84.SA.743.

The four works above
illustrate different ways of
TRUNCATING a sculpted BUST.
They reflect the four distinct
stylistic periods in which they
were created: Renaissance,
Baroque, early Neoclassical,
and Romantic.

used the sitter's garb or armor to determine the truncation. In
the Baroque period, artists sought to mitigate the inherent
artificiality of the truncated bust by employing sweeping curves
and flowing draperies that would soften or distract from the ter-
mination and lend the portrait a greater sense of physical volume
and lifelike animation. Although classicizing terminations
inspired by ancient Roman sculpture were widespread during the
Neoclassical period of the late eighteenth and nineteenth cen-
turies, proponents of a purer Grecian aesthetic regarded the
square HERM truncation as preferable to the traditional Roman
formula of a bust on a socle. By the mid-nineteenth century
sculptors had become increasingly innovative in their experi-
ments with bust terminations, often adopting unconventional for-
mulas that played upon the fragmentation inherent in the
sculpted bust or emphasized its status as an object.

Jean-Antoine Houdon
(French, 1741–1828).
Bust of Louise Brongniart,
c. 1777. Marble, H: 46 cm
(18⅛ in.). JPGM, 85.SA.220.

Jean-Baptiste Carpeaux
(French, 1827–1875).
Bust of Jean-Léon Gérôme,
1872–73. Marble, H: 60 cm
(23⅝ in.). JPGM, 88.SA.8.

UNDERCUT

A void on a sculpture created by a mass that protrudes over
the surface below it, forming a recess where MOLD materials can
become trapped. Because most complex sculptural forms involve
undercuts, piece molds or flexible mold materials are used to
take impressions of these surfaces.

WAX

A substance composed of esters, cerotic acid, and hydrocarbons,
which is derived from animal, mineral, or plant sources and is
chemically similar to fat. Beeswax was the primary wax employed
for sculpture. Because of its translucency, the ease and perma-
nence with which it can be colored by the addition of ground
dry pigments, and its ability to record detail, wax was suitable for
PORTRAITS as well as the depiction of religious, mythological, and
genre themes in which a great degree of realism was desirable. In
the eighteenth and nineteenth centuries, wax was used to create
highly accurate replicas of human anatomy for use in medical
schools. Pigmented wax was cast into plaster MOLDS (based on

WAX
Youth, Italian (possibly
Emilia), 1600–50.
Pigmented wax, H (inside
frame): 10 cm (3¹⁵⁄₁₆ in.);
W (inside frame): 8.1 cm
(3³⁄₁₆ in.). V&A, A.67–1938.

actual dissections) and enhanced with accurately colored, modeled details such as veins and tendons.

With the addition of plasticizers such as Venice turpentine and animal fat, wax becomes malleable at room temperature and can be freely and easily worked using the fingers and hot metal tools, making it a desirable medium for MODELS. Wax models used in LOST WAX CASTING were either modeled directly on a CORE or, more commonly, were SLUSH CAST or pressed into molds. Resin was often added as a hardener for casting.

When thinned with solvent, wax also serves as a coating that protects wood sculpture from cracking due to excessive fluctuations in humidity, metal from corroding due to salts and high humidity, and metal and marble from damage due to handling. Because beeswax remains soft and becomes acidic with age, synthetic waxes which are harder and more stable are now used as protective coatings. Wax coatings can be colored and brought to a high polish and often provide a final aesthetic treatment for bronze sculpture.

WOOD

A fibrous, durable substance that, underneath their bark, constitutes the trunk, stems, and branches of trees and shrubs. The many varieties of trees produce woods that differ considerably in color, hardness, density, and workability. Although a range of woods was used in European sculpture, walnut, oak, limewood (also called lindenwood or basswood), poplar, pearwood, boxwood, pine, and chestnut were the most common. When first cut,

wood contains a considerable amount of water and thus must be allowed to dry before it is carved (a process called *seasoning*). Wood is an unstable medium. Even after seasoning, it continues to dry slowly in addition to absorbing and releasing water in response to changes in humidity. As a result its cell walls shrink and swell, and the wood changes dimensions, often causing it to crack and warp. This tendency encouraged the use of smaller pieces from a single trunk in which the amount of dimensional change was diminished (although there are many cases where the entire hollowed-out trunk was used).

The strength of wood lies along the GRAIN, and compositions were usually planned so that carving would occur in this direction rather than across the grain. Tools used for wood carving include:

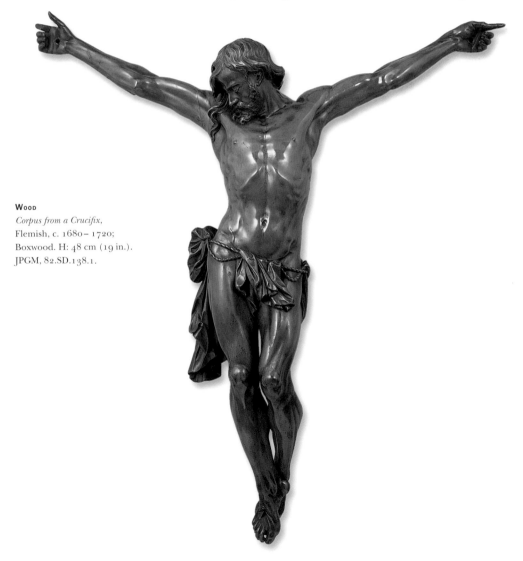

WOOD

Corpus from a Crucifix,
Flemish, c. 1680–1720;
Boxwood. H: 48 cm (19 in.).
JPGM, 82.SD.138.1.

the *axe* (blade positioned parallel to the handle), *adz* (blade at a right angle to the handle), and saw, used to work the tree or log down to the approximate size and shape of the piece(s) needed; gouges, DRILLS, chisels, files, *rasps* (a course file with cutting points), and *rifflers* (a file with cutting points, generally with two specially shaped, often curved ends) to further refine the form; and scrapers, planes, burnishers, carving knives, and abrasives to finish the surface. The circular saw and planing machine came into use in the nineteenth century.

Wood can be used for RELIEF sculpture or sculpture IN-THE-ROUND. Techniques for wood relief sculpture include *relief carving*, in which the background is carved away to reveal a raised relief; *incised carving*, in which the design itself is sunk below the surface; *chip carving*, which combines relief and incised carving, mostly for geometric designs; and *pieced carving* (also called *fretwork*), in which the background is cut out completely. Wood sculpture in-the-round is usually hollow and is often gilded and painted (see POLYCHROMY). Wood is susceptible to fire damage, insect damage, fungal decay (caused by constant dampness), and splitting or warping (due to excessive fluctuations, or a sudden, prolonged drop in humidity).

ZINC

A brittle, lustrous, bluish white metal. Although in early use as an alloying element of BRASS, zinc was not isolated as a pure metal in Europe until the mid-eighteenth century and became popular for cast sculpture only in the nineteenth century. Inexpensive zinc reproductions were executed using SAND CASTING, SLUSH CASTING, or stamping. Whereas sand casting was the earliest technique used for zinc and continued to be the most popular process for producing large, unique zinc sculptures, slush casting was used after 1845 for creating large EDITIONS or multiple casts. Molten zinc was slush cast into open bronze molds, and the cast sections were then joined with lead-tin solder. Once the bronze molds were made, the technique was quick, the zinc retained the details of the mold, and many copies could be made. Stamping involved pressing sheet zinc into shapes, usually to create decorative architectural pieces. Zinc sculpture was almost always coated to imitate other materials such as gold, bronze, stone, polychromed wood, or plaster. Coatings included oil GILDING, POLYCHROMY, and BRONZING. Zinc can also be chemically PATINATED, typically resulting in a black color. Because of its brittle and soft nature, zinc sculpture is susceptible to breakage and distortion. Although in clean air a stable zinc-carbonate layer forms on uncoated zinc, pollution will dissolve this protective coating, allowing corrosion to occur.

Agricola, Georgius. *De Re Metallica*. Translated from the
first Latin edition of 1556 by Herbert Clark Hoover and
Lou Henry Hoover. New York, 1950.

Cellini, Benvenuto. *The Treatises of Benvenuto Cellini on Gold-
smithing and Sculpture*. Translated by C. R. Ashbee. New York,
1967.

Finn, David. *How to Look at Sculpture*. New York, 1989.

Hoffman, Malvina. *Sculpture Inside and Out*. New York, 1939.

Hughes, Richard, and Rowe, Michael. *The Coloring, Bronzing, and
Patination of Metals*. New York, 1983.

Kingery, David, and Vandiver, Pamela. *Ceramic Masterpieces*.
New York, 1986.

Leithe-Jasper, Manfred. *Renaissance Master Bronzes from the Collec-
tion of the Kunsthistorisches Museum, Vienna*, exh. cat. London,
1986.

Penny, Nicholas. *The Materials of Sculpture*. New Haven and
London, 1993.

Pope-Hennessy, John. *Italian High Renaissance and Baroque
Sculpture*. London and New York, 1970.

Pope-Hennessy, John. *Italian Renaissance Sculpture*. London and
New York, 1971.

Radcliffe, Anthony. *European Bronze Statuettes*. London, 1966.

Rich, Jack. *The Materials and Methods of Sculpture*. New York, 1974.

Ritchie, Carson. *Ivory Carving*. London, 1969.

Rockwell, Peter. *The Art of Stoneworking: A Reference Guide*.
Cambridge, 1993.

Wasserman, Jeanne, ed. *Metamorphoses in Nineteenth-Century
Sculpture*. Cambridge, 1975.

Wittkower, Rudolf. *Sculpture: Processes and Principles*. New York and
London, 1977.

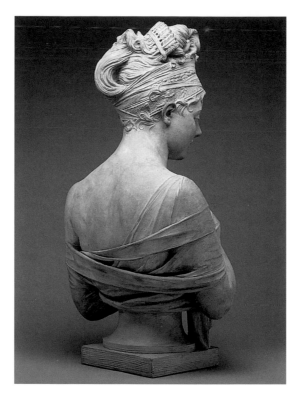

Joseph Chinard (French, 1756–1813).
Bust of Madame Récamier, c. 1801–02. Terra-cotta,
H: 63.2 cm (24⅞ in.).
JPGM, 88.SC.42.

Cynthia Newman Bohn, Editor

Kurt Hauser, Designer

Stacy Miyagawa, Production Coordinator

Jack Ross (JPGM) and Christine Smith (V&A), Photographers

Typeset by G&S Typesetters, Inc., Austin, Texas

Printed by C&C Offset Printing Co., Ltd., Hong Kong